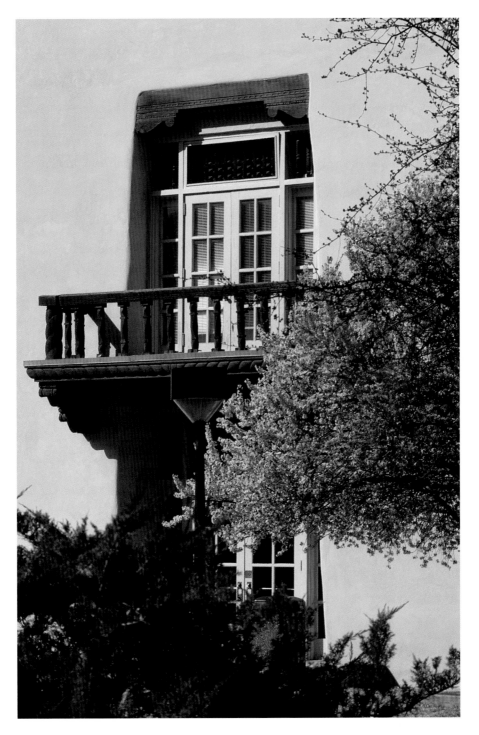

TEXT BY V. B. PRICE
PHOTOGRAPHS BY ROBERT RECK

~~~~~~~~~~~~~~~~~~~~~~~~~~~~~~~~~~~~~~~~~~

PRODUCED BY VAN DORN HOOKER

UNIVERSITY OF NEW MEXICO PRESS | ALBUQUERQUE

# THE UNIVERSITY
## OF NEW MEXICO

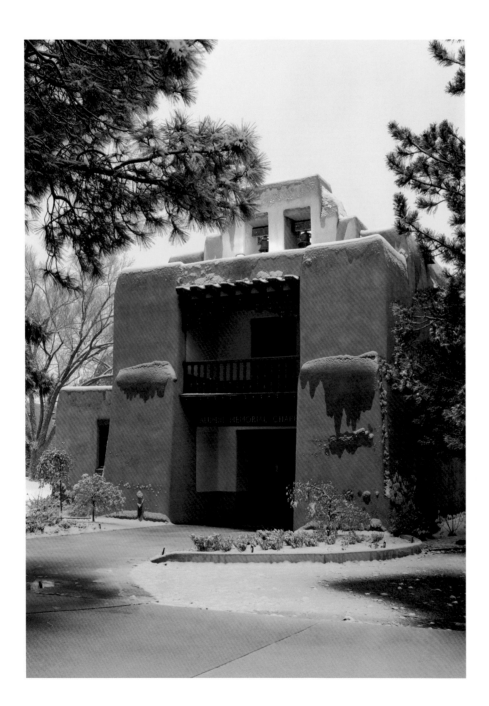

LIBRARY OF CONGRESS CATALOGING-IN-PUBLICATION DATA

Price, V. B. (Vincent Barrett)

The University of New Mexico /

text by V.B. Price

and photographs by Robert Reck

produced by Van Dorn Hooker.

   p.  cm.

ISBN 978-0-8263-4812-8 (cloth : alk. paper)

1. University of New Mexico—Pictorial works.

2. University of New Mexico—History.

I. Reck, Robert, 1945–

II. Title.

LD3781.N533P75 2009

378.789'61—dc22

2009030304

Printed and bound in China by Everbest Printing Company, Ltd. through
Four Colour Imports, Ltd.  •  Design and compostion: Melissa Tandysh

Photographs pages 76 (left), 84–85, 114, 115, 116, and 117 by Mary Elkins
Photographs pages 74, 80, and 118–19 by Jon Freland

~~~~~~~~~~~~~~~~~~~~~~~~~~~~~~

HALF-TITLE PAGE: SCHOLES HALL, SOUTHWEST ENTRANCE
TITLE PAGE: THE ALUMNI MEMORIAL CHAPEL

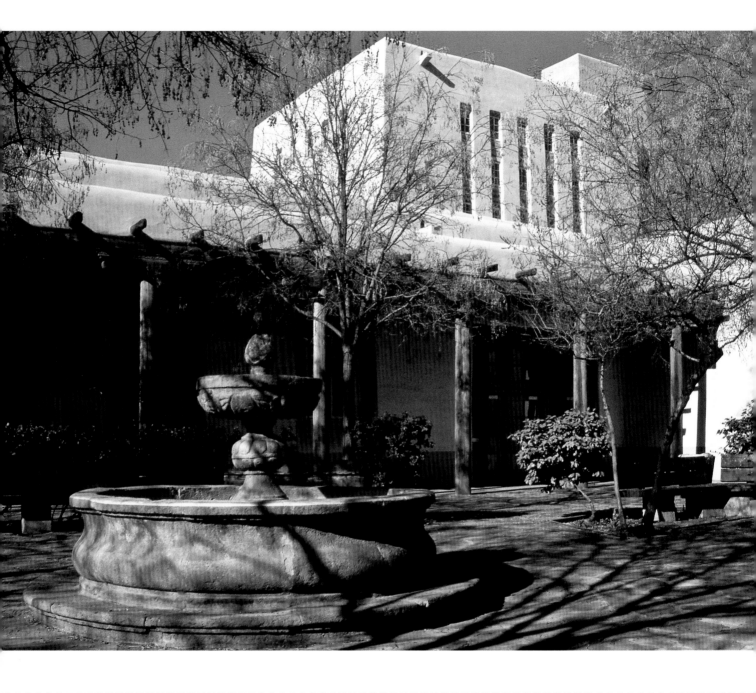

ZIMMERMAN LIBRARY PATIO, SOUTH SIDE

A LETTER FROM THE PRESIDENT

In pictures and in words, this book captures the essence of the University of New Mexico. On the following pages, you will see the beauty found on the UNM campus, with its signature architecture that is so reflective of the history of this state. You will also be treated to glimpses of the education of tomorrow as we envision it today. UNM is a place where we teach and learn, where we study and reflect, where we research, discover, and analyze. It is also a place to paint, to perform, and to play.

Looking through this book, you will share what photographer Robert Reck saw through his lens. We now invite you to see it all for yourself. Come stroll our malls, visit our fine museums and libraries, meditate in our Alumni Memorial Chapel, and relax by our duck pond. Enjoy what UNM has to offer for it is truly amazing.

One of my revered predecessors, Tom Popejoy, once wrote, "It takes more than the profile or outward appearance of the building to make a university, but if aesthetics mean anything in the intellectual development of students, and I feel certain that it does, then the University of New Mexico has an asset which gives it a unique position among the institutions of the nation."

The University of New Mexico is now 120 years old and promises to survive and thrive for many more centuries—as long as there is a Land of Enchantment. It is my honor and privilege to share the state's flagship university with you. May this book bring you pleasure and a feeling of pride in UNM.

Sincerely,
David J. Schmidly
President

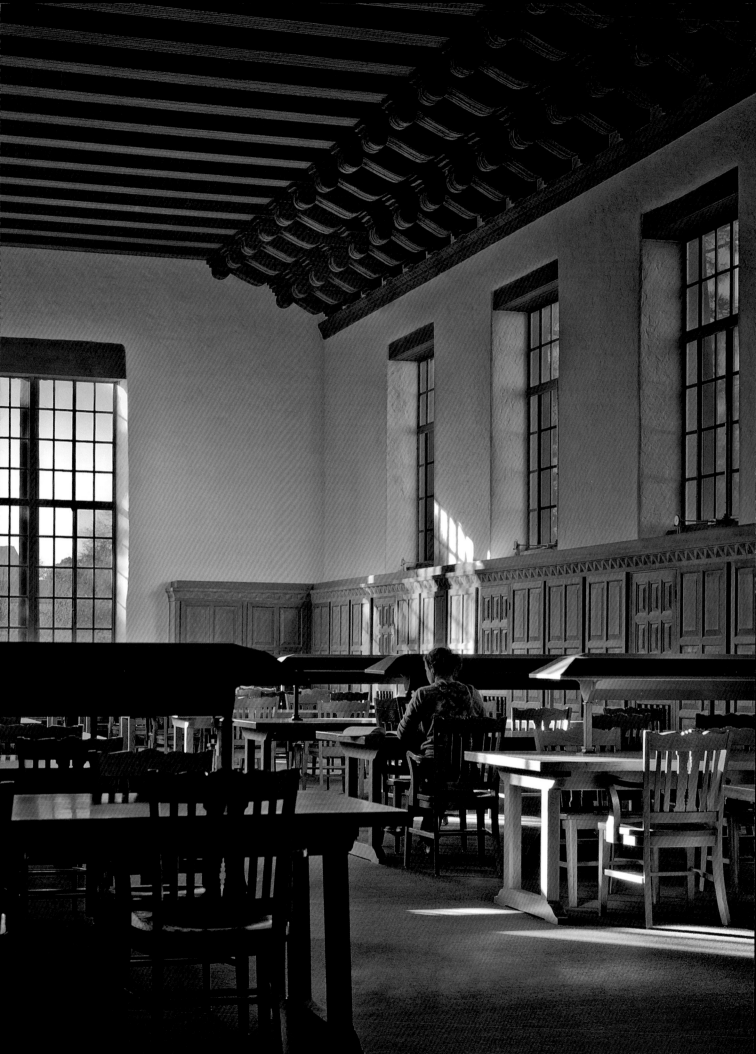

THE UNIVERSITY OF NEW MEXICO

SINCE ITS FOUNDING ON THE SAND HILLS ABOVE DOWNTOWN
Albuquerque in 1889, the University of New Mexico has graduated thou-
sands of students who have been the mainstays of New Mexico's economic,
political, and cultural life. The heart and soul of Albuquerque, and beloved
by its alumni across the country and around the world, UNM has always
had the pride of a triple mission—to serve and promote the well-being
of the citizens of its state, to be the institutional champion of the unique
richness and fascinating beauty of New Mexico's myriad cultures, and to
distinguish itself as a major American research university capable of mak-
ing world-class contributions in the arts and sciences.

Most universities inspire feelings of affectionate loyalty among their
graduates. But with UNM, as with New Mexico, there's something more,
something that sets both the state and its oldest university a notch above
the rest. While it's hard to describe that quality, one could say that the uni-
versity embodies the love of place. For many, UNM is much more than an
alma mater. It has *querencia*, a place in our hearts, like a homeland. UNM
does not impose itself on the cultural, physical, and historic landscape of
the southwest. It arises from it. From the church-like reading rooms in the
old Zimmerman Library, designed after the interiors of a mission church at

READING ROOM—ZIMMERMAN LIBRARY

Acoma Pueblo, to the gracious, protective, and welcoming enclosure of the school's central plaza and interior lake, known fondly as the duck pond, UNM is proud *of* its place. I'm talking not just about a sentiment or a promotional image. People who know the cultures of New Mexico, from Pueblos and Hispanic villages to ranch lands and the National Laboratories, will find them gracefully coexisting on the main campus, with the modern world always paying its respects to the past.

Much of UNM's mystique is embodied in the main campus. It's one of the high mountain West's great walking environments—both nurturing and inspiring, much like the University itself. The campus environment is internationally admired for its unique Spanish/Pueblo Revival style architecture, blended respectfully with contemporary modernist buildings. Designed to exclude automobiles from its inner core, the main campus is an oasis of cultured civility, at once brimming with the youthful vigor of its student body and rooted in the American West's most venerable social and aesthetic traditions. It's what makes UNM an academic symbol of the mind-opening sense of enchantment that New Mexico is known for around the world. UNM's cutting-edge vitality in literature, fine arts, physics, biology, anthropology, medicine, law, engineering, and dozens of other fields gives voice to the rich diversity and genius of the people of New Mexico.

New Mexico is the original Hispanic heartland of North America. Spanish settlers coming up from Mexico colonized the region well before the English and Dutch established themselves on the East Coast. The state is one of the few places in North America where indigenous Native American populations have withstood the pressures of European conquest to remain culturally viable and politically influential. Owing to New Mexico's relative isolation, which has contributed to its long history of top secret scientific investigation, the state has more PhDs per capita than any other in the nation. With only two million people, New Mexico is home to a vital community of writers, poets, scholars, physicists, architects, musicians, painters, and sculptors. The focus for much of this talent is the synergistic context of the University.

When a visitor enters UNM's main campus, walking north past the sleek regional modernist-style building called George Pearl Hall, the new Antoine Predock designed School of Architecture and Planning, or enters from the west past the Spanish/Pueblo style Alumni Chapel and the historic landmarks of Scholes Hall and Zimmerman Library, all initially designed by regionalist architect John Gaw Meem and his associates, the complexity of New Mexico's cultural landscape becomes apparent. But there's much more to UNM than its architectural metaphors of New Mexico's diversity.

The state's flagship university and major research institution, UNM is a center of academic excellence and community service. In 2006, for instance, *U.S. News and World Report* listed the UNM School of Medicine in the top fifteen primary-care–oriented medical schools in the nation, ranking the UNM Health Sciences Center's curriculum second overall in Rural Medicine, third in Nursing Midwifery, fifth in Family Medicine, sixth in Primary Care, and fifth in Community Health. Such rankings underline UNM's emphasis on community service.

The University's Clinical Law Program is ranked fifth nationally. The Carnegie

GEORGE PEARL HALL FROM THE FRONTIER RESTAURANT

Foundation rated UNM recently "very high" as a research university, and UNM is in the top rank of engineering and science research and development expenditures according to the National Science Foundation. Graduate programs in Electrical and Computer Engineering were ranked fourteenth in the nation by the 2008 *Princeton Review*. For a relatively small school with under 30,000 students in a state with a population of just over two million people, UNM consistently ranks higher in many fields than other universities in the West.

The Anderson School of Management is considered by *Hispanic Business Magazine* to be one of the nation's ten top business schools for Hispanics. And the Anderson School's Management of Technology MBA program is ranked sixth in the world. The graduate program in photography, a department with a long, distinguished history, is ranked by *U.S. News and World Report* as number two in the nation. Between 1996 and 2000, the research impact of material science publications produced by UNM faculty was listed fifth out of the top hundred federally funded universities in the country.

New Mexico's image as a place of unique creative energy, and a bastion of southwestern art and culture, is due in good part to UNM's intense institutional focus on southwestern

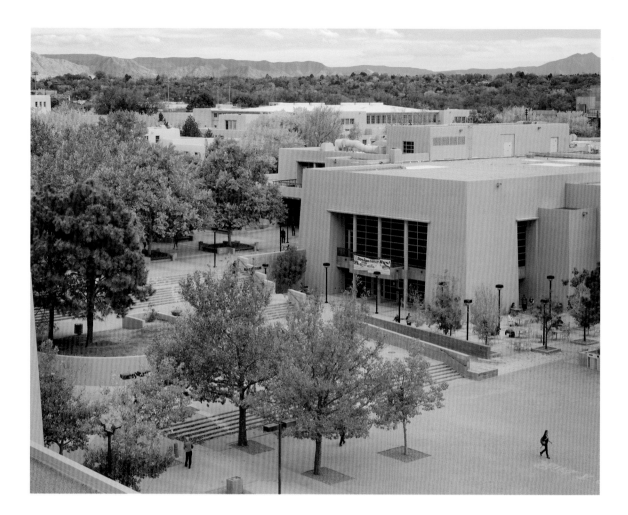

CORNELL MALL

issues and creative talent since the early twentieth century, when the school adopted its Spanish Pueblo Revival style architecture and found itself referred to as the Pueblo on the Mesa. For many decades, UNM was an oasis of local culture in the heart of a fast growing American city. While this image of UNM remains in the forefront, even in modern Albuquerque with its 700,000 plus people, it has been continually expanded since the end of World War II by the presence and influence of a formidable scientific establishment at Los Alamos and Sandia National Laboratories. Sandia Labs' interest in alternative energy, laser engineering, and other applied technology, has played its part in infusing UNM with state-of-the-art research projects across many other disciplines as well.

In 2008, the Pueblo on the Mesa's Physics Department was given a $1.1 million grant

from the W. M. Kack Foundation to build an optical scanning nanoscope to examine living cells. A study of UNM's fifty-five research centers was carried out by the Educational Research Information Center in 1999 to determine how academic research programs transfer technology to private businesses. In 2006, UNM's library created the Indigenous Nations Library Program, reaching out to UNM's Native American community. In 2008, UNM entered into a partnership with Harvard University, the Southwestern Indian Polytechnic Institute, and the Albuquerque Public Schools to educate and train minority students in biomaterials research.

The University operates the High Performance Computing and Research Center, which supports the Albuquerque Research Center contracts with the Department of Defense and the Department of Energy. UNM's Center for Global Environmental Technologies supports R & D and information transfer dealing with stratospheric ozone depletion, global warming, and the protection of the global commons. UNM maintains the Sevilleta Long Term Ecological Research Center in the Sevilleta National Wildlife Refuge, studying how chemicals and other physical factors impact arid-land ecosystems like New Mexico's. And in 2002, UNM's diabetes research and treatment centers, focusing on New Mexico's disproportionately high incidence of the disease, were nationally recognized.

The list of UNM's scientific research accomplishments is extraordinarily rich and full, dating to the 1930s. But it was in the social sciences, specifically anthropology, that UNM first distinguished itself academically, and in architecture that UNM first set itself apart creatively.

The school's architectural history is legendary in New Mexico and revered in the world of university planning. And it derived, substantially, from the University's early emphasis on southwestern archaeology. Longtime University Architect Van Dorn Hooker documented the history of campus planning and design at UNM in his book *Only in New Mexico*, published by UNM Press in 2000. The story begins, in brief, with UNM's visionary third president William George Tight who, in 1908, collaborated with architect E. B. Cristy and transformed the University's first major structure, Hodgin Hall, from a brick Romanesque building into something resembling a prehistoric pueblo. Pueblo culture in New Mexico is urban and has a long history of architectural achievement extending back to the eleventh century A.D. in Chaco Canyon and other sites. The Tight/Cristy partnership set the tone for later Pueblo style buildings designed by John Gaw Meem and his staff during the WPA era. Van Dorn Hooker, who had worked in Meem's office, guided UNM's expansion from 1963 to 1987, integrating the work of New Mexico's modernist architectural community with the buildings of the Pueblo on the Mesa. Hooker catalyzed a modern regionalism on campus that will allow the University to expand into the future and remain true to its southwestern heart and soul.

While Tight and Cristy were independent scholars of ancient Pueblo archaeology, it wasn't until twenty years after their initial building program that President James F. Zimmerman established the Department of Anthropology, for which UNM remains deservedly famous. With New Mexico being the site of the greatest number of pre-Columbian ruins in North America, numbering over ten thousand, UNM's

anthropology department was focused early on the riches of southwestern Pueblo, Navajo, and Apache cultures. The first faculty member in the department, and its chair, was Edgar Lee Hewett, one of the founders of the Santa Fe style in the state capital, a founder of the Museum of New Mexico, and first director of the School of American Research. President Zimmerman and Professor Hewett bargained successfully for UNM to purchase three of New Mexico's most famous archaeological sites—Chaco Canyon, the Salinas Missions south of Albuquerque, and Coronado Monument just north of Bernalillo—so students could get invaluable fieldwork experience at world-class sites. UNM's Anthropology Museum became Albuquerque's first public museum in 1932 and was renamed the Maxwell Museum of Anthropology forty years later. Some of the southwest's greatest anthropologists were associated with UNM, including Hewett, Florence Hawley Ellis, Alfonso Ortiz, Lewis Binford, Stanley Newman, W. W. Hill, Clyde Kluckhohn, and Leslie Speir.

With the creative melding of southwest archaeology and regional architecture, UNM's commitment to creativity became a leading part of its institutional focus. In later years, UNM's School of Architecture and Planning, while not espousing regionalist design, focused much of its attention on design solutions for modern landscape architecture and building practices in the arid southwest. The goals of the school's community and regional planning program, in which students and faculty are advocates for rural communities and participate in long-range, regional grassroots planning, are in keeping with UNM's emphasis on building

the state's economic base and serving its often disadvantaged rural populations.

The creative synergy between architecture and anthropology at UNM is mirrored in the poetry, prose, photography, painting, and lithography that has made UNM a major center of the creative arts for the last fifty years. The English Department's writing program has made an important contribution to American letters. Under the leadership of former Los Angeles poet Gene Frumkin and the Chicano master Rudolfo Anaya, along with the frequent association of poet Robert Creeley with UNM, the school catalyzed several generations of New Mexican, Native American, and Latino writers in the United States, among them Native American poets Simon Ortiz, Lucy Tapahanso, and Joy Harjo, and world-class Chicano author Jimmy Santiago Baca. Under the aegis of UNM, dozens of writers from New Mexico to California have created a florescence of regional literature in New Mexico and the Native American and Hispanic southwest. Novelist Tony Hillerman, who taught for years in the UNM Journalism Department, helped to give credence to Native American themes in his mysteries set in the Navajo world. Rudolfo Anaya's *Bless Me Ultima* has become an international classic. UNM's creative writing department is one of the prime reasons why New Mexico is the home of so many award-winning writers to this day. With its *Blue Mesa Review*, a department-edited national literary magazine, the English Department has helped UNM's ongoing effort to strengthen, honor, and reveal the cultural uniqueness of the state.

One of UNM's more remarkable departments is UNM Press, known for many years as one of the top university presses in the country. Publishing some eighty-five books a year,

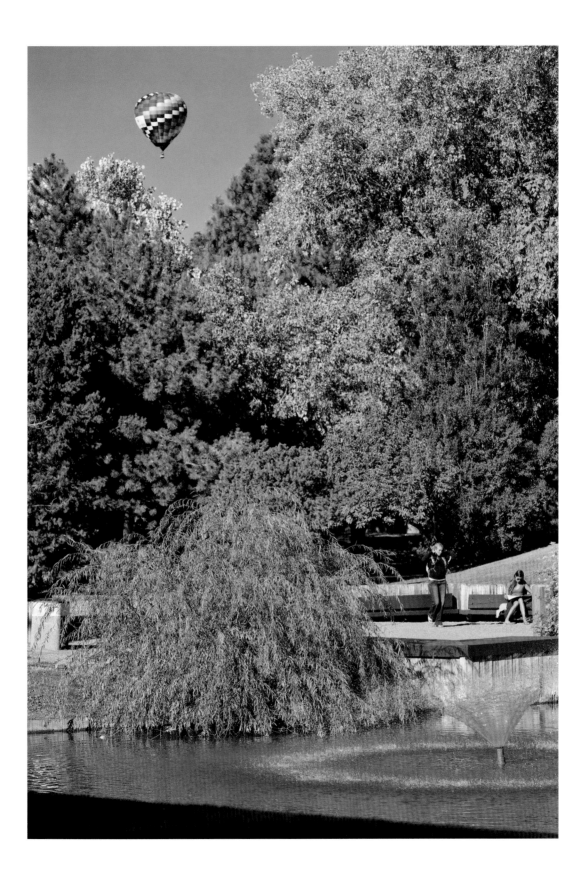

HOT AIR BALLOON OVER DUCK POND

many of them award-winning titles, the Press competes with the publication efforts of universities with a financial clout many times greater than that of UNM's. Known for its emphasis on photography, art, Chicano literature, western history, archaeology, and Latin American history, UNM Press has nurtured the creative life of New Mexico since 1929. For years the Press published the *New Mexico Quarterly*, a nationally known literary journal. A recent sampling of its many award-winning books includes *New Mexico's Crypto Jews*, by Cary Herz, named the Best Nonfiction Book—Religion by the National Federation of Press Women and Rudolfo Anaya's children's book *The First Tortilla*, winner of the Land of Enchantment Book Award. Sam Quinones, author of UNM Press's *Antonio's Gun and Delfino's Dream*, won the Maria Moors Cabot Prize for Outstanding Reporting on Latin America and Caribbean for 2008, awarded by the Columbia University Graduate School for Journalism. The Press's commitment to New Mexico extends to publishing poetry through the Mary Burritt Christensen Poetry Series, which in early 2002 featured an anthology of New Mexico poets since 1960 called *In Company*.

In the fine arts, Tamarind Institute has brought the University of New Mexico worldwide recognition. Tamarind has played a central role in the renaissance of fine art lithography. Brought to UNM in 1970 by then Dean of Fine Arts Clinton Adams, Tamarind has worked for more than forty years to transform lithography from a medium used to merely reproduce images to a creative collaboration between master printers and creative artists. Tamarind-trained printers now staff more than two hundred professional print workshops across the country.

The Tamarind Book of Lithography has become the "standard technical reference found in printmaking studios not only in the U.S. but also from Moscow to Mexico City," says Tamarind Director Marjorie Devon. The Institute's catalogues have been translated into Spanish, Chinese, Italian, and several Slavic languages. Tamarind's archives contain prints from the thousands of artists who have collaborated with master printers at UNM over the years, coming to work from all over the world in Albuquerque and UNM's warm collegial environment. As is often the case, Tamarind's reputation is probably greater in other parts of the country and world than it is in New Mexico.

The same might be said for the UNM Honors Program. Founded in 1961 by then Dean of Arts and Sciences Dudley Wynn, the UNM Honors Program has evolved into one of the top two honors departments in the country. Dean Wynn helped to found the National Collegiate Honors Council (NCHC) and was the guiding spirit of honors education leading to the revival of small, liberal arts college settings within larger land-grant universities. Most of UNM's honors program directors, including Rosalie Otero, the program's present director, have served as presidents of the NCHC over the years. UNM's honors program has created a welcoming environment in which multidisciplinary topics are taught in seminar settings of no more than sixteen students. The close-knit community of honors students, the honors faculty and visiting professors, and the program's intense intellectual atmosphere create lifelong bonds of friendship. Most of UNM's winners of prestigious Rhodes, Truman, Marshall, and Goldwater scholarships in recent years have been mentored by the Honors Program faculty, and the vast majority of the school's student

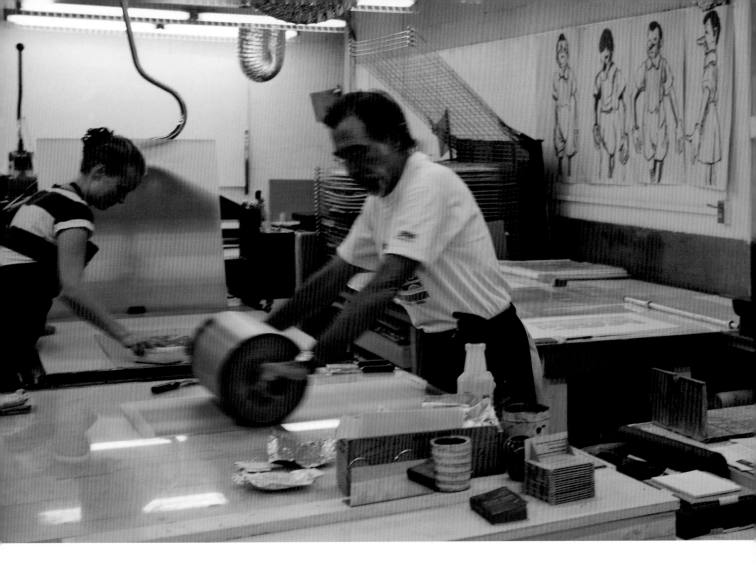

Regents and Presidential Scholars are honors students. With its own Honors Center and one of the few tenured honors faculties in the nation, the Honors Program helps students, especially outstanding freshmen, start their experience at UNM in both a challenging and nurturing way. International travel and research experiences sponsored by the Honors Program include summer fieldwork on the biodiversity of Australia, a program of comparative study of human and natural history in the Rockies and the Andes, and an intensive summer program of language and culture studies in Mexico. UNM honors students also have the opportunity to learn production, editing, and management skills publishing the only major honors magazine in the country. *Scribendi*, an award-winning annual, staffed and produced exclusively by UNM honor students, publishes the work of students from some two hundred colleges and universities in eleven western states in association with the Western Regional Honors Council. That the Honors Program would produce a high quality magazine that publishes the work of young people from universities far larger and better funded is emblematic of UNM.

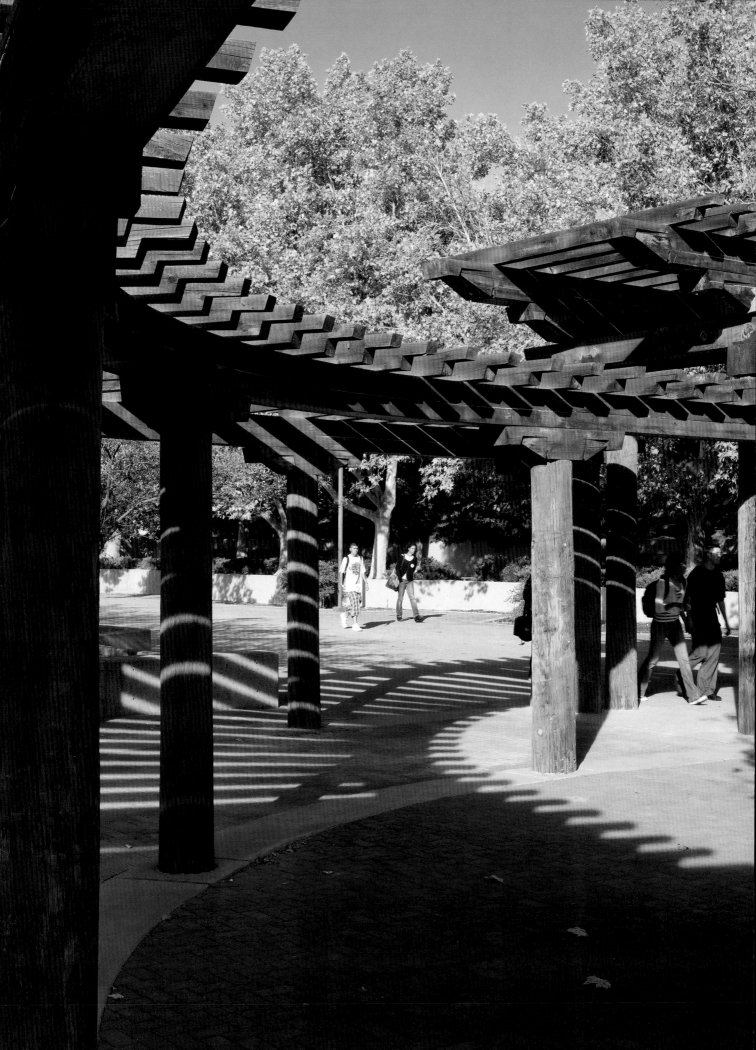

UNM is one of a relatively small number of American universities to have a degree-granting Department of Native American Studies. Chaired by Gregory Cajete from Santa Clara Pueblo, a prolific author who has written on native science and Native American ecology, the program involves indigenous language and education, indigenous arts and literature, indigenous leadership and self-determination, and indigenous cultural and environmental studies. UNM's Chicano, Hispano, Mexicano Studies Program concentrates on small farm acequia culture and water management in northern New Mexico, as well as on the history, folkways, ethnography, and linguistic traditions of Hispanic New Mexico.

When it comes to national reputation, UNM's MFA graduate program in photography ranked second in 1995 and third in 1997 in the nation, according to *U.S. News and World Report* surveys of top faculty and administrators in 190 other art schools and departments. UNM switched places with the School of the Art Institute of Chicago. The Rochester Institute of Technology was first, but UNM was ahead both years of the prestigious Rhode Island School of Design and Yale University. UNM's photography program was a pioneering and visionary enterprise in the early 1960s when Fine Arts Dean Clinton Adams hired photographer and art historian Van Daren Coke to become art department chair and director of the UNM Fine Arts Museum. Coke worked to help make the study of photography a serious academic endeavor. When one

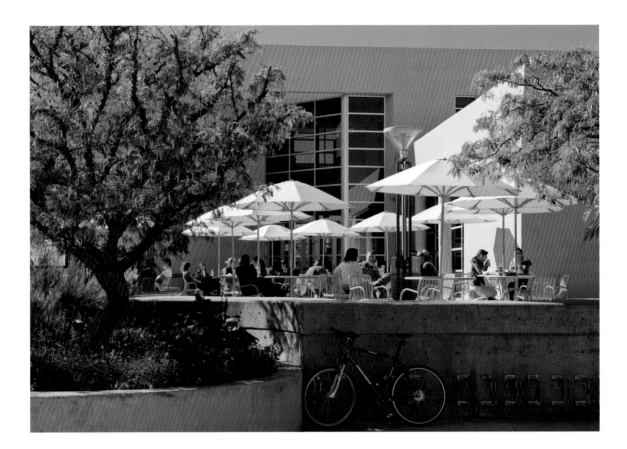

〰〰〰〰〰〰〰

STUDENT UNION BUILDING

of America's most respected photo histori-
ans, Beaumont Newhall, joined the faculty
in the 1970s, the program attained interna-
tional esteem. Although the department is not
devoted to regional aesthetics, the New Mexico
landscape, creative traditions, and high-tech
culture have always made the state a magnet for
great photographers.

In a similar way, UNM became famous
for the rarified but intriguing hybrid
scientific disciplines of archaeoastronomy
and ethnoastronomy, thanks to the work of
UNM Presidential Scholar Michael Zeilik,

who explored Pueblo moon watching and
the astronomical calendrical architecture of
Chaco Canyon and other ancient pre-Pueblo
sites. Such work would not have been possible
without the historic cultural richness of New
Mexico. The UNM Department of Physics
and Astronomy, where Zeilik worked, is
also known for its scholarship in optics and
photonics, biological physics, and condensed
matter physics. The department's Institute
for Astrophysics operates the Capilla Peak
Observatory in the Manzano Mountains. The
Capilla Peak facility was built by department

founder Victor Regener, who served as its chair from 1947 to 1957 and again from 1962 to 1979. Regener fled Nazi Germany in 1938. He taught in Italy and at the University of Chicago before coming to UNM in 1946. Another of UNM's most renowned scientists, Lincoln La Paz, worked during World War II as a research mathematician at the old New Mexico Proving Grounds outside Albuquerque, now Kirtland Air Force Base. La Paz joined the Astronomy and Physics faculty in 1945 and founded the Institute of Meteoritics. A prolific researcher, La Paz discovered numerous new meteors and served as a consultant to the Air Force investigating many supposed UFO sightings.

When it comes to regional history and political science, UNM has always taken a leadership role. The Carnegie Initiative on the Doctorate selected the UNM History Department in 2003 to be part of an on-going research and policy project that works to improve American doctoral programs by creating, among other things, experimental initiatives to meet new graduate study goals. With the Rio Grande Valley Teaching American History Grant from the U.S. Department of Education, the department works to help teachers earn master's degrees in history. The department is also the home of the *New Mexico Historical Review*, the most distinguished scholarly journal of its kind in the state, and the interdisciplinary Center for the Southwest. The faculty of the Political Science Department has played an active role in New Mexico's civic life for years. Distinguished Professor F. Chris Garcia is a familiar, fair-minded, and trusted election night analyst on local television, and retired Professor Fred Harris, a former U.S. Senator from Oklahoma and presidential candidate,

brings his populist wisdom to bear on many issues in the state.

Since the mid-1940s, UNM's Music Department has had a profound impact on Albuquerque and New Mexico, helping to foster the state's passionately loyal classical music audience. As a result, the sparsely populated state has one of the very few 24-hour classical music radio stations in the country, KHFM. Longtime UNM Symphony conductor and professor Kurt Frederick was also an early conductor of the New Mexico Symphony Orchestra from 1945 to 1950, a founder of the Albuquerque Youth Symphony, and a co-founder of Opera Southwest and the Albuquerque Opera Theatre. Frederick conducted the Albuquerque Civic Symphony's American premier of Arnold Schoenberg's "A Survivor from Warsaw." Renowned musicologist John Donald Robb, a dean of the UNM Art Department from 1942 to 1957, collected over 3,000 field recordings of traditional folk songs across the state. His book, *Hispanic Folk Songs of New Mexico*, remains the authoritative source on the topic.

Latin American Studies at UNM began in 1941. Today the Latin American and Iberian Institute is a major national center for Hispanic studies. It is the home of the Latin American Data Base, an online scholarly information source on Latin America politics, business, and culture. Begun in 1983 by UNM sociology professor Nelson P. Valdes to fill a void in accessible information about the rich cultures south of our border, the database has grown into national resource. Thanks to the Latin American and Iberian Institute, UNM was one of the first universities in the country to offer undergraduate and graduate degrees in Latin American Studies.

New Mexico also fosters ultramodern cutting-edge science and engineering. UNM's Centennial Engineering Center opened in September 2008. The school's many departments reflect New Mexico's scientific and technological interests, including chemical and nuclear engineering, computer science, and computer engineering. Also in 2008, the School of Engineering, along with Boston University and the Rensselaer Polytechnic Institute of Troy, New York, began a partnership under the National Science Foundation to operate an Engineering Research Center to explore new kinds of energy-saving technologies. The Engineering School is also involved in biomedical engineering, investigating complexity theory and complex systems, and exploring the development of a solar car. It often works closely with the state's national laboratories.

On UNM's north campus, with its sleek modernist medical library and more traditional law school buildings, world-class work is being accomplished by UNM scholars. The medical school, established in 1961, has long been known as one of the major innovators in medical education, pioneering the primary care curriculum, a mentorship and hands-on approach to teaching medicine that has students interacting with patients almost from the start. The medical school is a leader in the mountain west in cancer and diabetes research and care. Its focus is service, helping New Mexico students and patients of all incomes, and its rural and family medicine outreach is consistently ranked in the top echelons nationally. The School of Medicine serves students in other mountain states that have no medical education facilities, such as Idaho, Montana, and Wyoming. For a state with a

small population and low per capita income, New Mexico and its flagship university have made far more of the state's modest fiscal resources than one might imagine possible.

The School of Law, for instance, is also nationally recognized, in Clinical Law, Indian Law, and natural resources and environmental law. It's the top law school for Hispanic students in the nation. The Indian Law Program offers a certificate in Indian Law, operates the Southwest Indian Law Clinic, and publishes the *Tribal Law Journal*. Its students come from New Mexico's nineteen Pueblos and from Navajo and Apache tribes, along with Southern Colorado Utes, and others. The School of Law is known for its rigorous small-sized classes with an enviable student-teacher ratio of ten to one. Its alumni include numerous federal and state judges as well as justices of the New Mexico Supreme Court, the late Congressman Steven Schiff, New Mexico Attorney General Gary King, and U.S. Senator Tom Udall.

In the world of finance and big business, UNM's Anderson School of Management is linked to its namesake Robert O. Anderson, chief executive officer and chairman of the board of Atlantic Richfield Company. An oil and gas wildcatter, Anderson first came to Artesia, New Mexico, in 1941, purchasing an oil refinery there. The Robert O. Anderson School of Management was named for him in 1974 in tribute to his long history of charitable, business, and cultural leadership. Like the schools of law and medicine, the Anderson School specializes in serving the New Mexico community with its high-quality MBA programs. UNM is also the home of the Bureau of Business and Economic Research, which produces outstanding statistical reports and analysis on

ZIMMERMAN LIBRARY

New Mexico's economic climate. In 2008, the Bureau released its South Valley Incorporation Feasibility Study, one of many such in-depth analyses of local and regional issues important to New Mexico's business and political communities.

UNM's South Campus is the home of perhaps the school's most famous feature, the basketball arena known as The Pit, a semi-subterranean structure that has seen numerous NCAA regional championships in both men's and women's basketball, plus the NCAA Men's March Madness final in 1983. The Pit's noise level is something of an acoustical phenomenon, and its views of the court, unencumbered by posts and other impediments, are great from any seat in the house. The sports complex contains not only UNM's Pit, but its football stadium and new track and field stadium and soccer complex.

Also on the South Campus is UNM's Science and Technology Park (STP), 163 acres that was

established in 1965. The STP is symbolic of UNM's commitment to state-of-the-art science and technology research. UNM's top-five ranking in the rate of growth in National Institute of Health funding is indicative of this emphasis. As UNM likes to point out, "the University belongs to New Mexico's remarkable community of research and R&D facilities: Sandia National Laboratories, Los Alamos National Laboratory, the Air Force Research Laboratory, the National Center for Genome Research in Santa Fe, the Santa Fe Institute, Intel, Honeywell, Johnson and Johnson, and The Mind Institute. UNM researchers benefit from a cross-fertilization of ideas in this rich base of intellectual and entrepreneurial talent."

The mark of any university is the caliber of its graduates. UNM's alumni are rich in talent and accomplishment. Two recent New Mexico governors—Jerry Apodaca and Gary Johnson—are alumni. Long serving U.S. Senator Pete Domenici is a graduate of the class of 1954. Former Albuquerque Mayor Martin Chavez and Houston Mayor Bob Lanier are both alumni. Shirley Hufstedler, former U.S. Secretary of Education, was a 1945 graduate. Former astronaut Frank Borman; F. Chris Garcia, the seventeenth President of UNM; Ben Hernandez, former Ambassador to Paraguay; Ed Lewis, founder and publisher of *Essence* magazine; Tommy Jewell, the first African American judge of the New Mexico District Court; Francine Neff, former Secretary of the Treasury; Dennis Jett, U.S. Ambassador to Peru and Mozambique; and Petra Jimenez Maes, the first Hispanic woman to serve on the New Mexico Supreme Court are all alumni of UNM.

Artistically, UNM graduates are of the highest caliber, including American abstract expressionist painter Richard Diebenkorn, who received a graduate degree from UNM's art department in the mid-1950s; Chicano master storyteller Rudolfo Anaya, a 1963 graduate; mystery writer Tony Hillerman; Sarah Greenough, Curator of Photography at the National Gallery in Washington, D.C.; and novelist Leslie Marmon Silko.

For a school that can't afford to emphasize the full range of athletics in the way that a UCLA or a Notre Dame might, UNM has had a remarkable share of world leading athletes: Olympic Champion swimmer Cathy Carr in the 1972 Olympics, bronze medalist and 400 meter hurdler Dickie Howard in the 1960 Rome Olympics, Adolph Plummer, who broke the world record and psychological barrier in the 440 yard dash at 44.9 seconds, Luc Longley, center for the NBA Champion Chicago Bulls, Don Perkins, the Lobo running back who turned New Mexicans into Dallas fans as he ran for the Cowboys and joined their Ring of Honor in Texas Stadium, and Chicago Bear Brian Urlacher, the NFL's leading linebacker.

When UNM was created by the state legislature in 1889, "the Territory of New Mexico was still a wild frontier," former UNM President Bud Davis wrote in his history of UNM, *Miracle on the Mesa*. "The Albuquerque of the 1880s," Davis wrote, "was a trade and railroad center, a far cry from the metropolis it would become a century later." But Bernard Shandon Rodey, a young attorney and state legislator, fought tenaciously for the creation of the school, and wrote the authorizing legislation, which included these words: "The object of the University . . . shall be to provide the inhabitants of the Territory of New Mexico and the future state the means of acquiring a thorough knowledge of the various branches

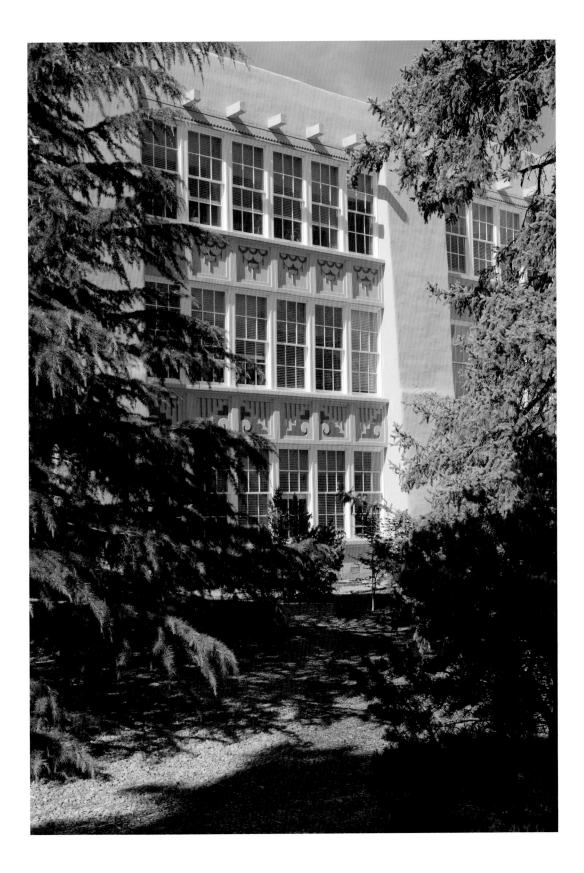

SCHOLES HALL, NORTH SIDE

of literature, science, and arts." That was quite a call for a city and territory that had seen the coming of the railroad not nine years earlier. But because of New Mexicans' pride and self-respect, and their love of place, UNM evolved into a major American university, overcoming its geographical isolation and the relative poverty and rural circumstances of much of its small population. UNM has risen above its means, driven by New Mexico's cultural tenacity, its spirit of self-improvement, and the cosmopolitan expansiveness fostered by dozens of Spanish language newspapers, as well as by writers and artists from around the state and nation. World War II brought UNM into the mainstream of international science. Its greatest president, Tom Popejoy, courageously defended freedom of speech and academic independence during the 1950s and 1960s, grounding the university in sound and honorable principles. During the 120 years of its existence, UNM has kept one goal above all others in mind—to serve New Mexico and its citizens directly, with research, teaching, outreach programs, and the spirit of excellence that a major American university brings to its community.

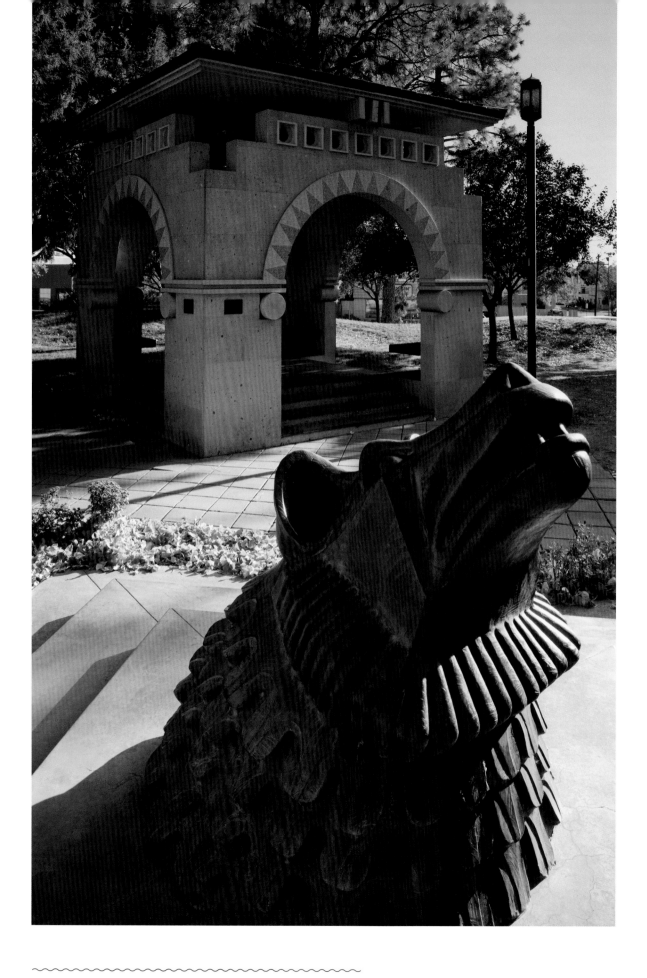

GAZEBO GIFT OF GOVERNMENT OF MEXICO WITH LOBO

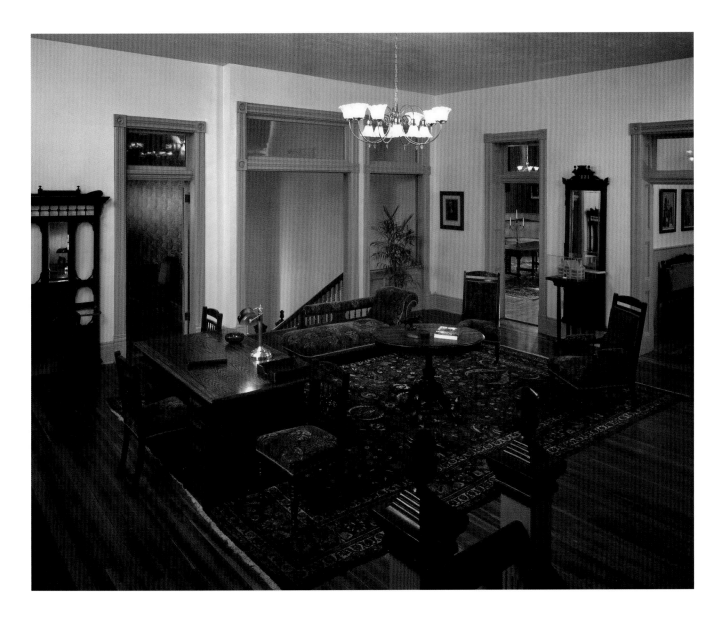

HODGIN HALL

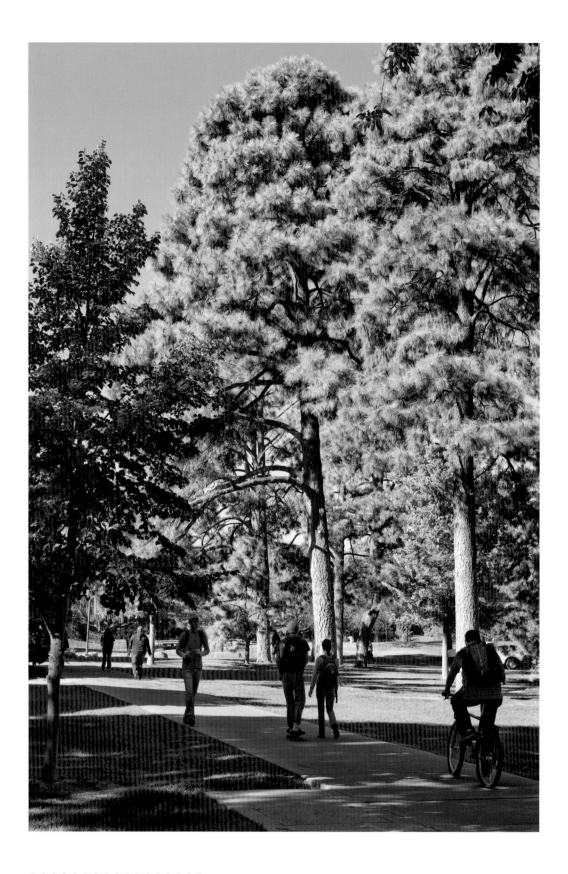

STUDENTS AMONG THE PINES

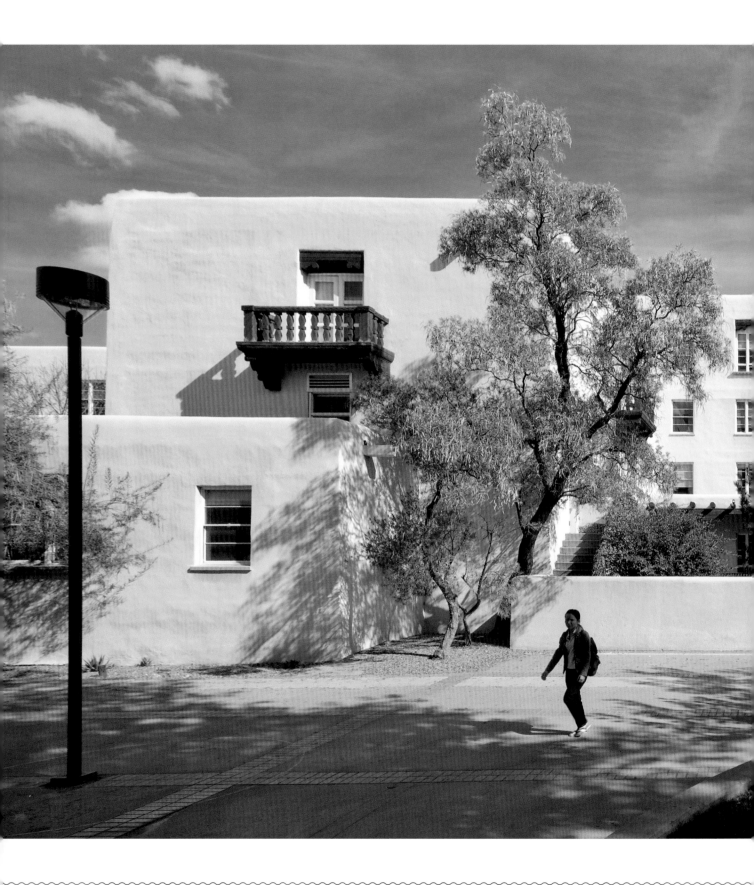

MESA VISTA HALL

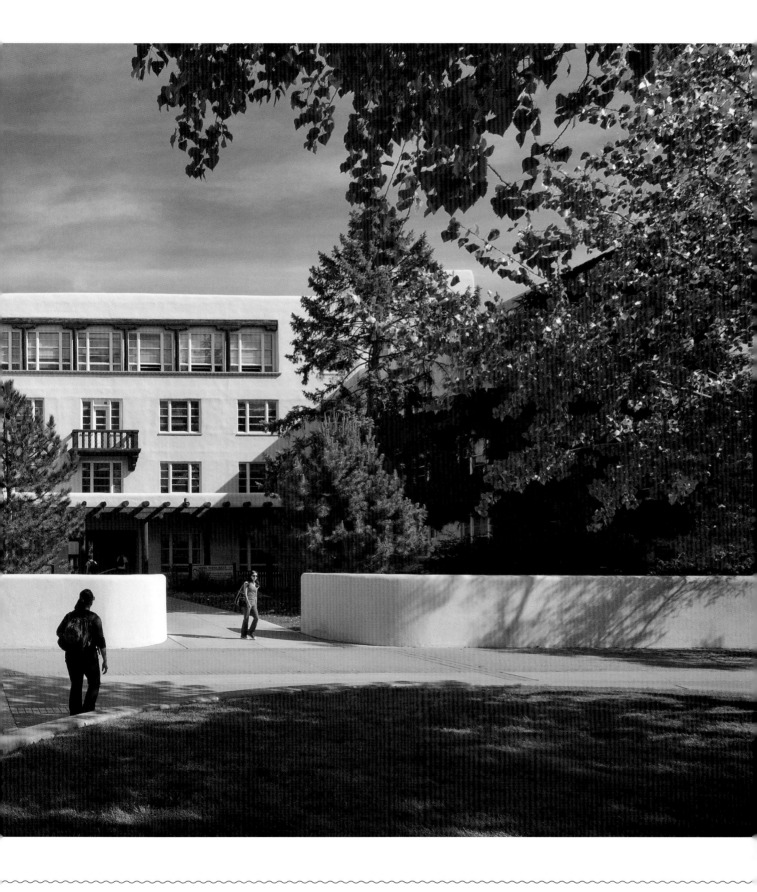

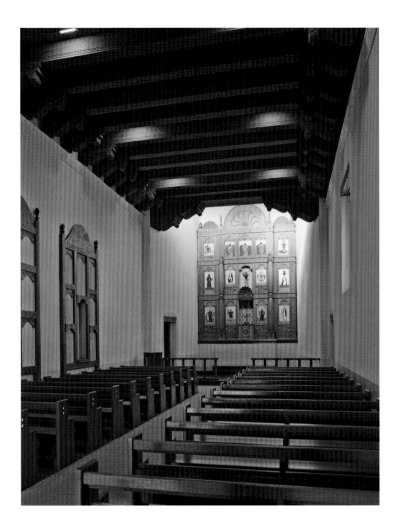

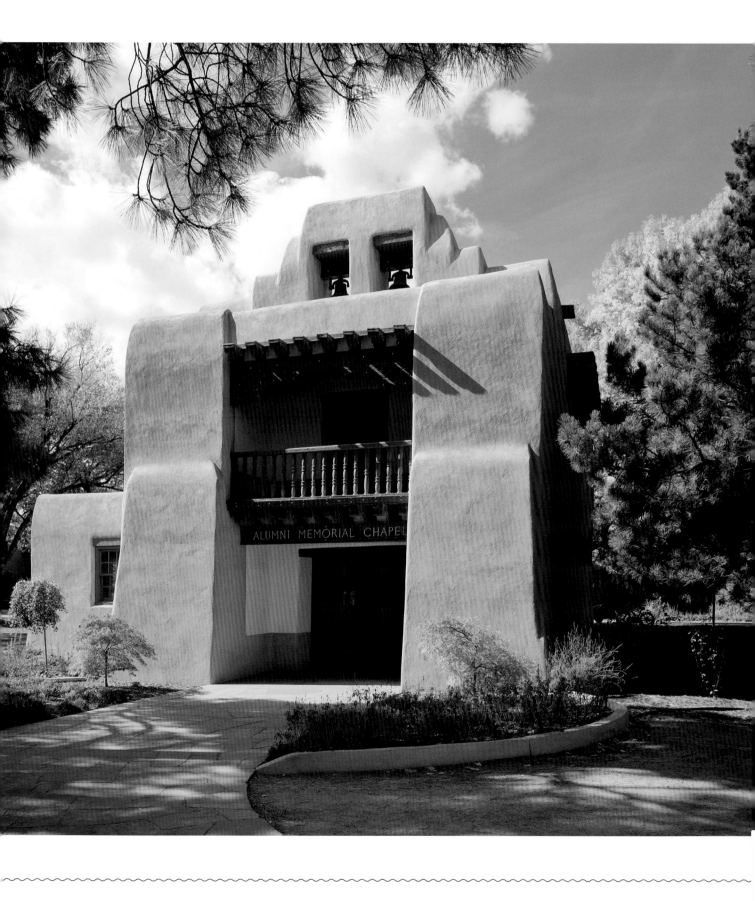

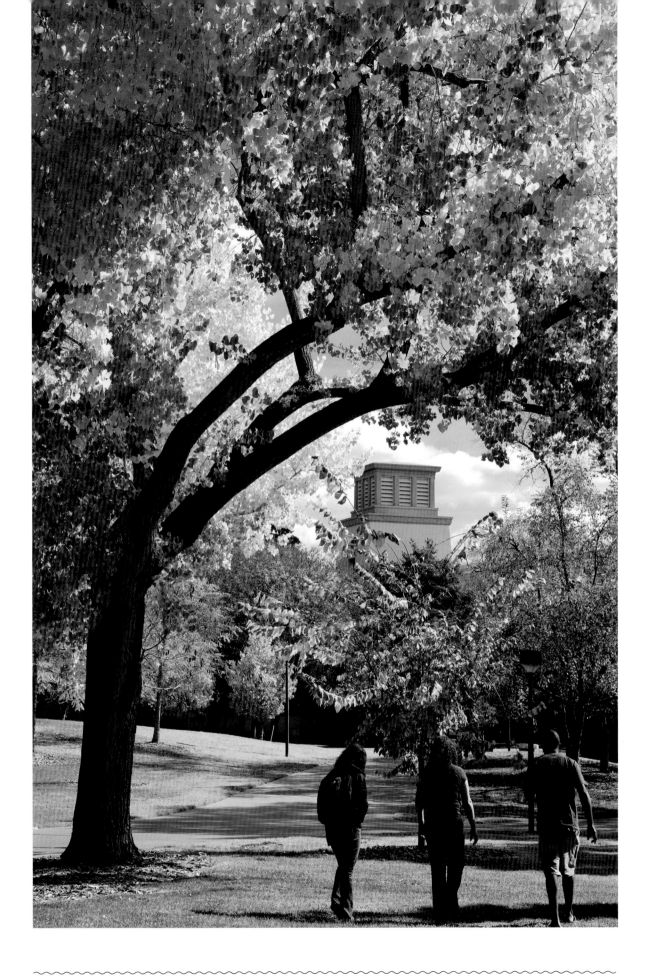

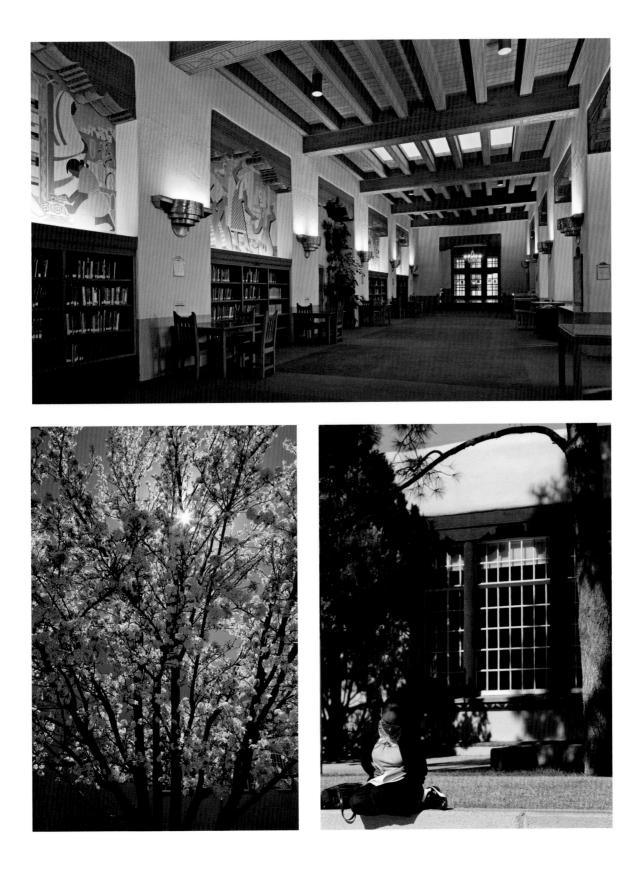

ZIMMERMAN LIBRARY, INTERIOR AND EXTERIOR

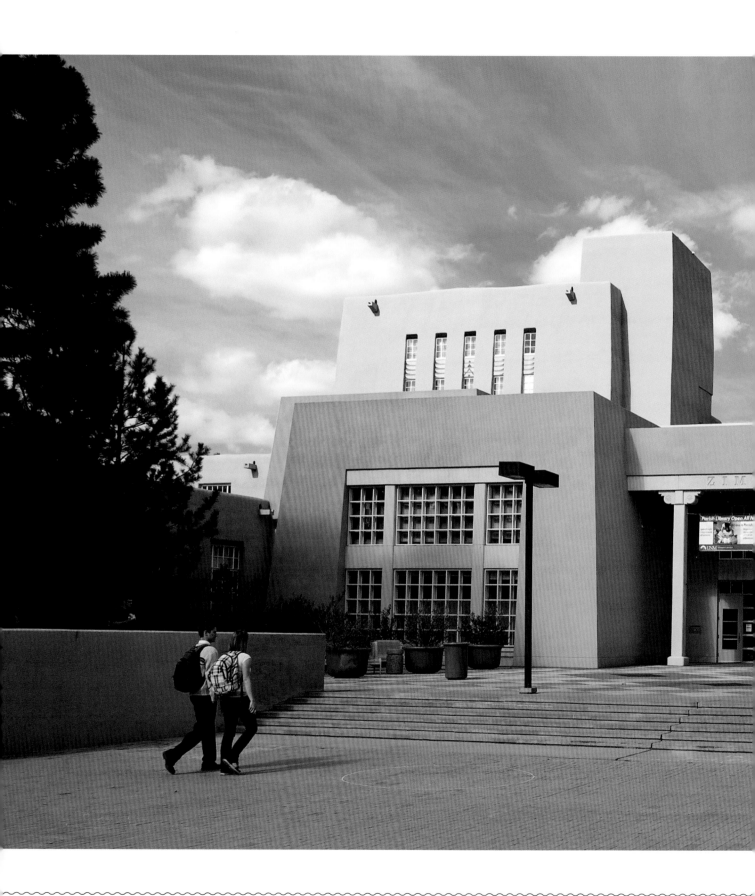

ZIMMERMAN LIBRARY

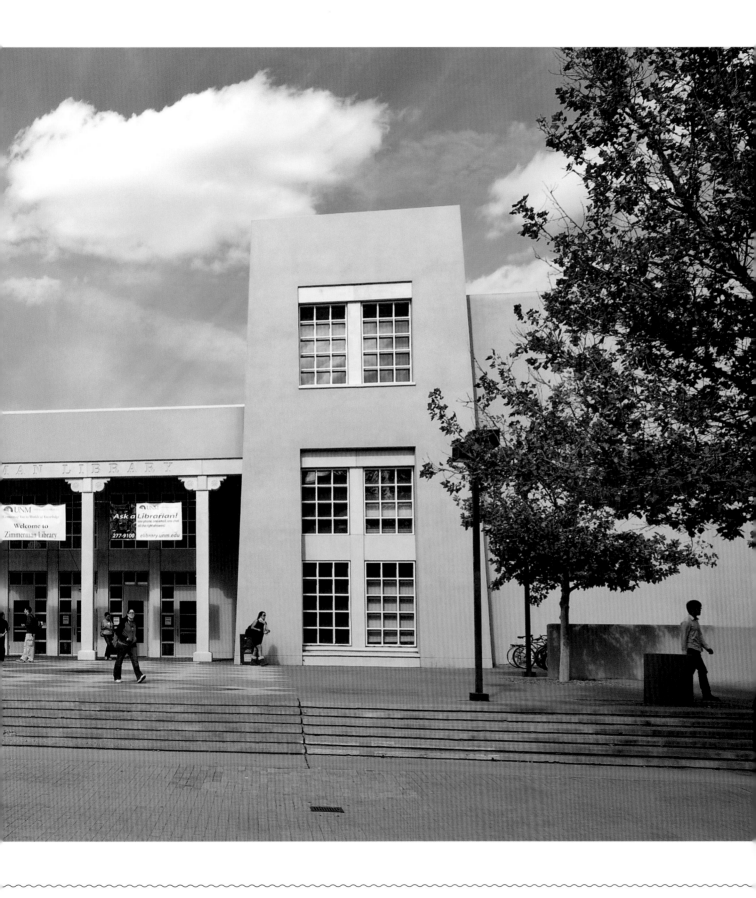

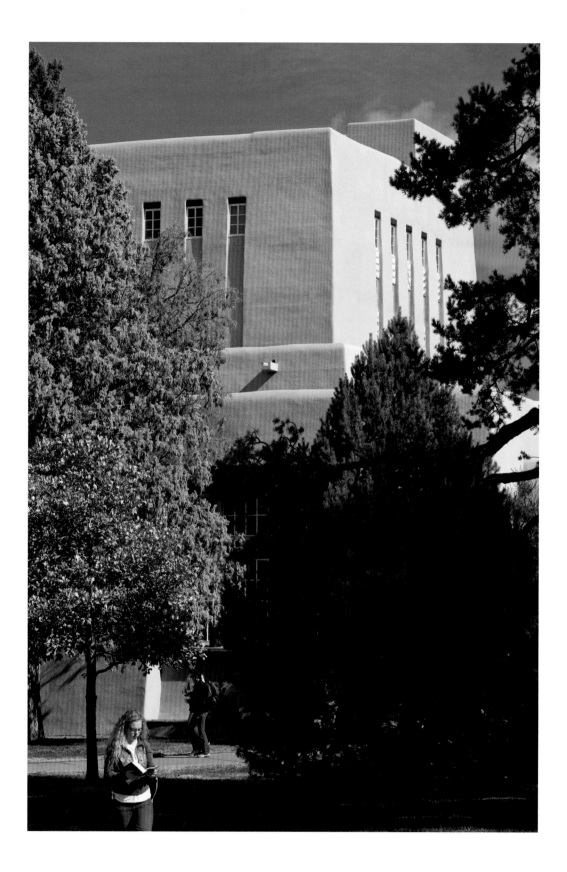

ZIMMERMAN LIBRARY TOWER

SCHOLES HALL

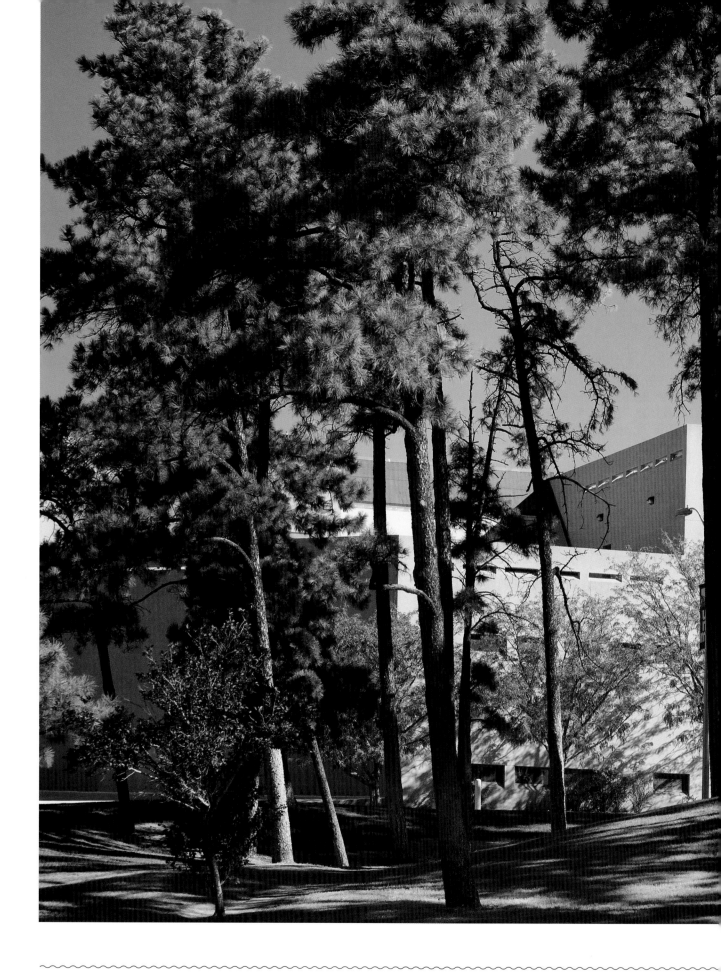

TIGHT GROVE

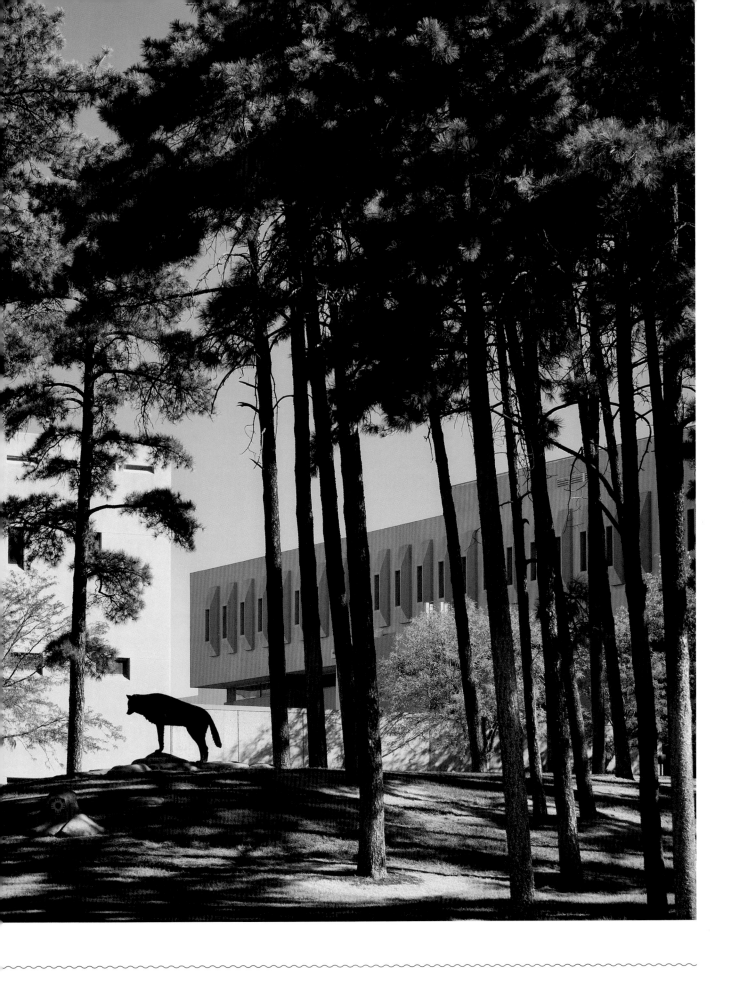

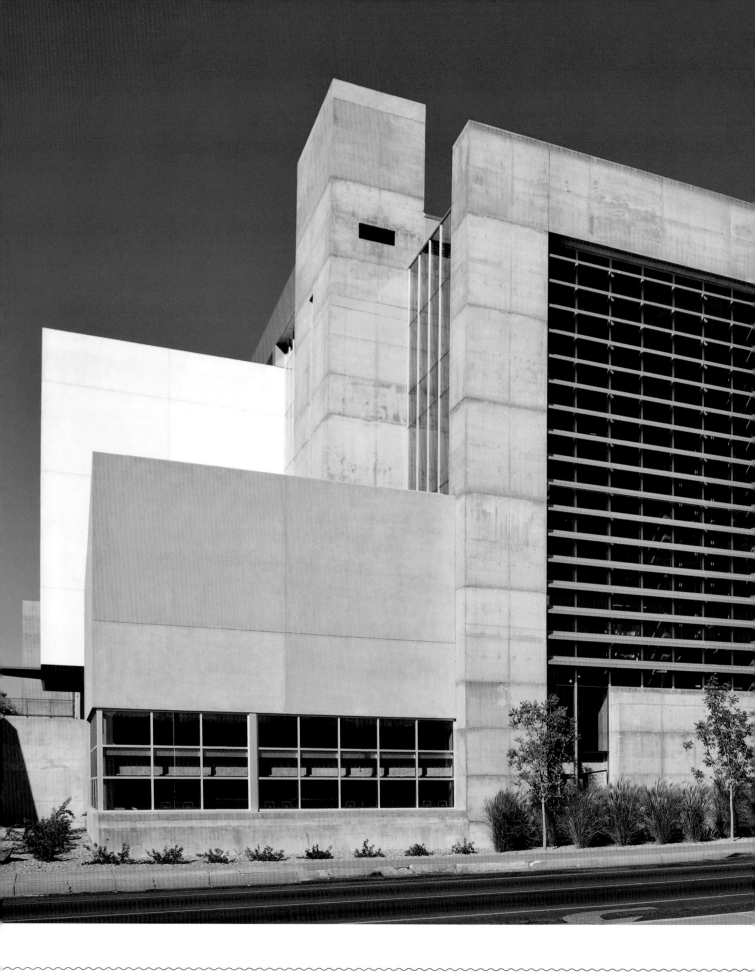

▲ GEORGE PEARL HALL

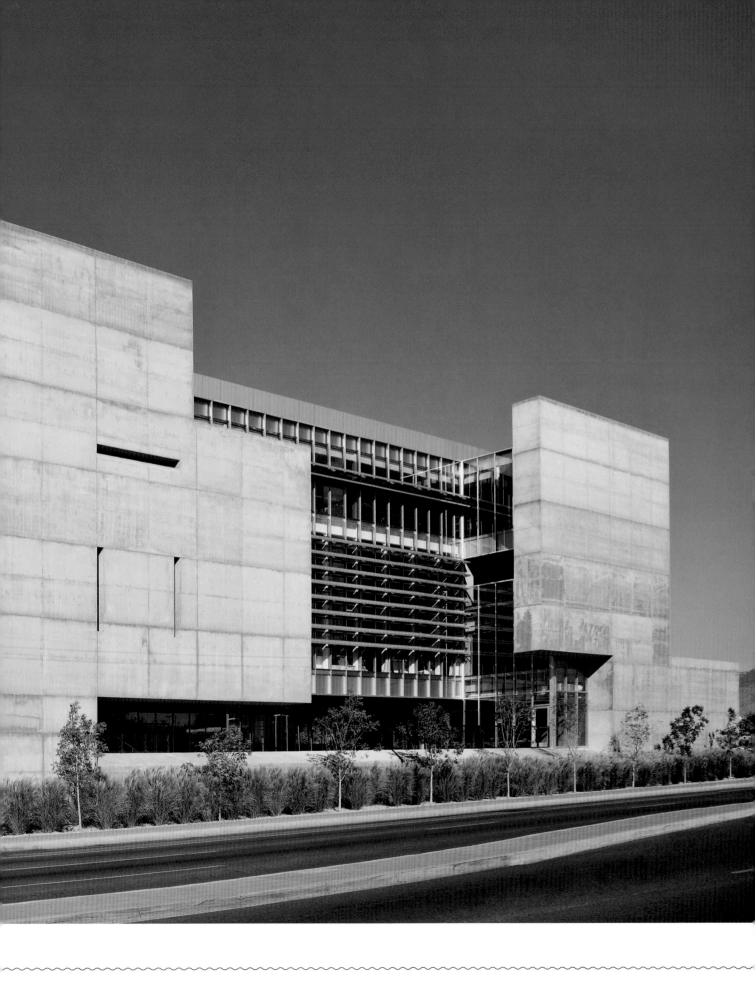

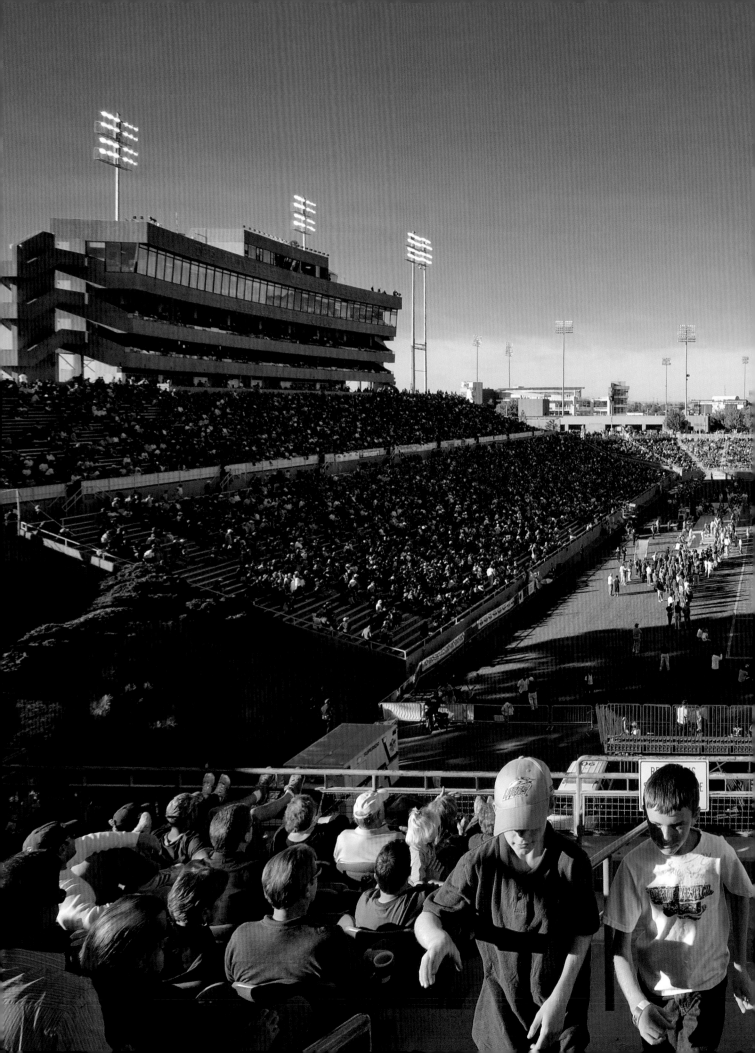

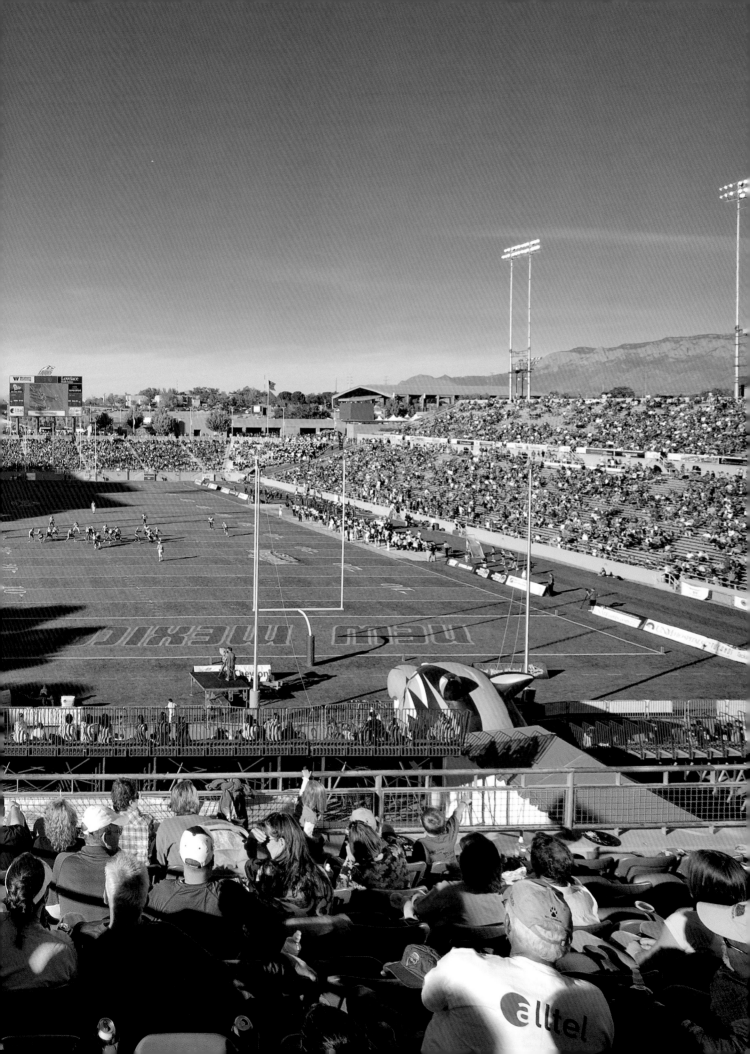

COLLEGE OF EDUCATION

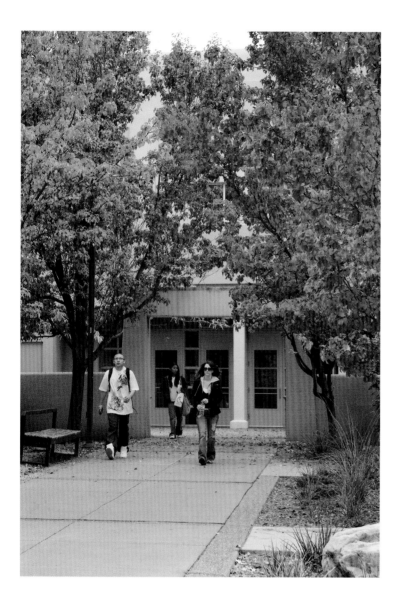

ZIMMERMAN LIBRARY, NORTH ENTRANCE

▲ DANE SMITH HALL

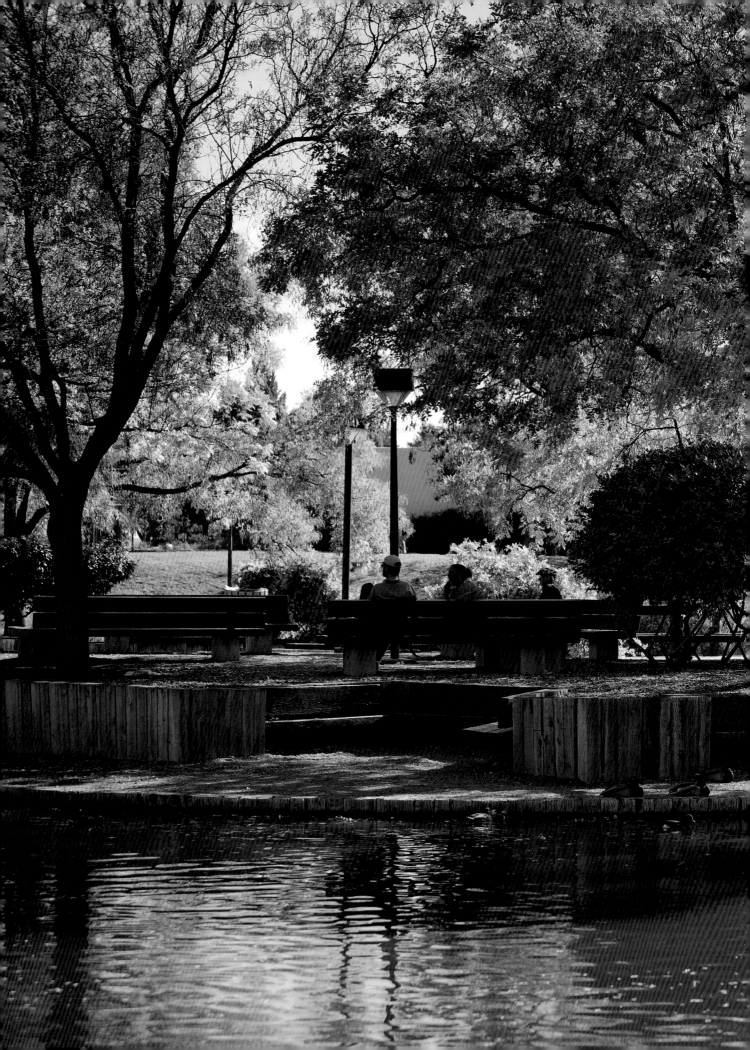

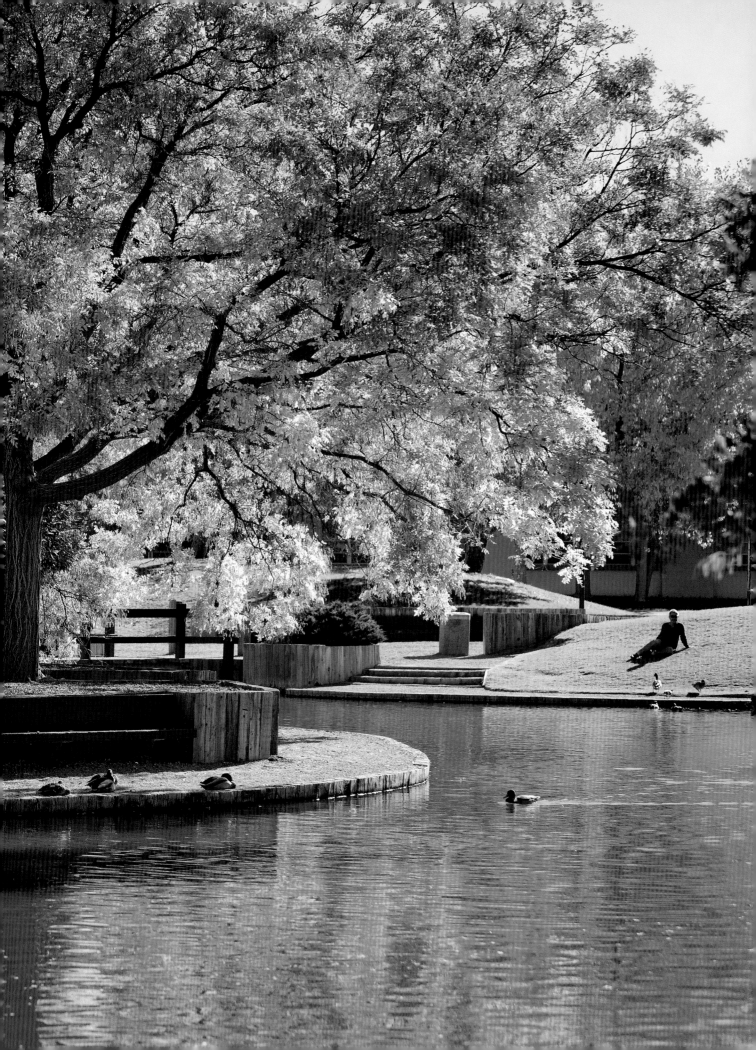

▲CONCERT IN POPEJOY HALL

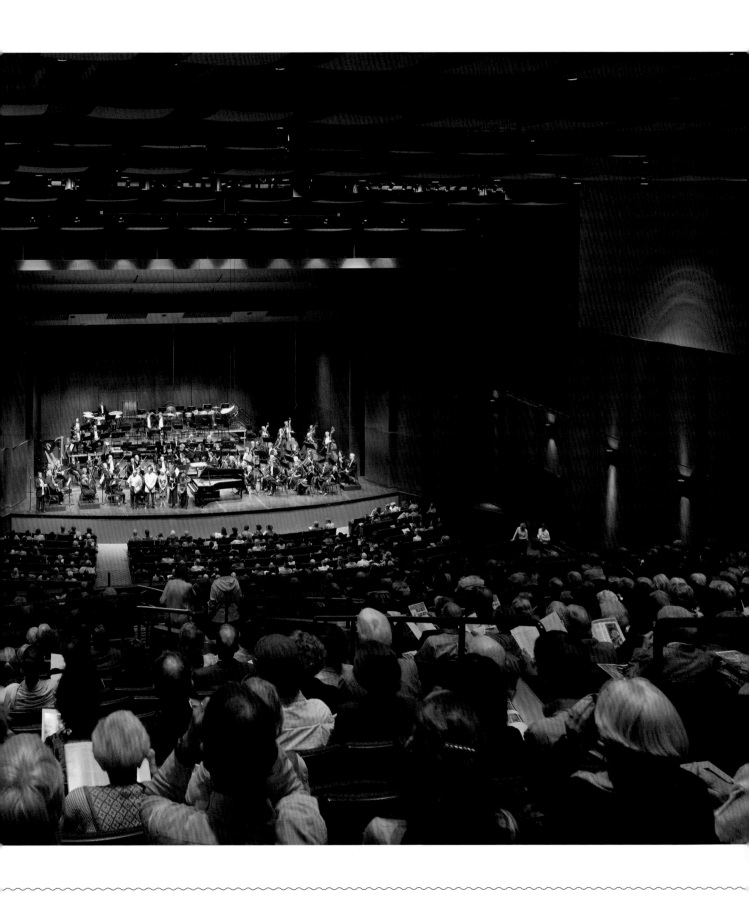

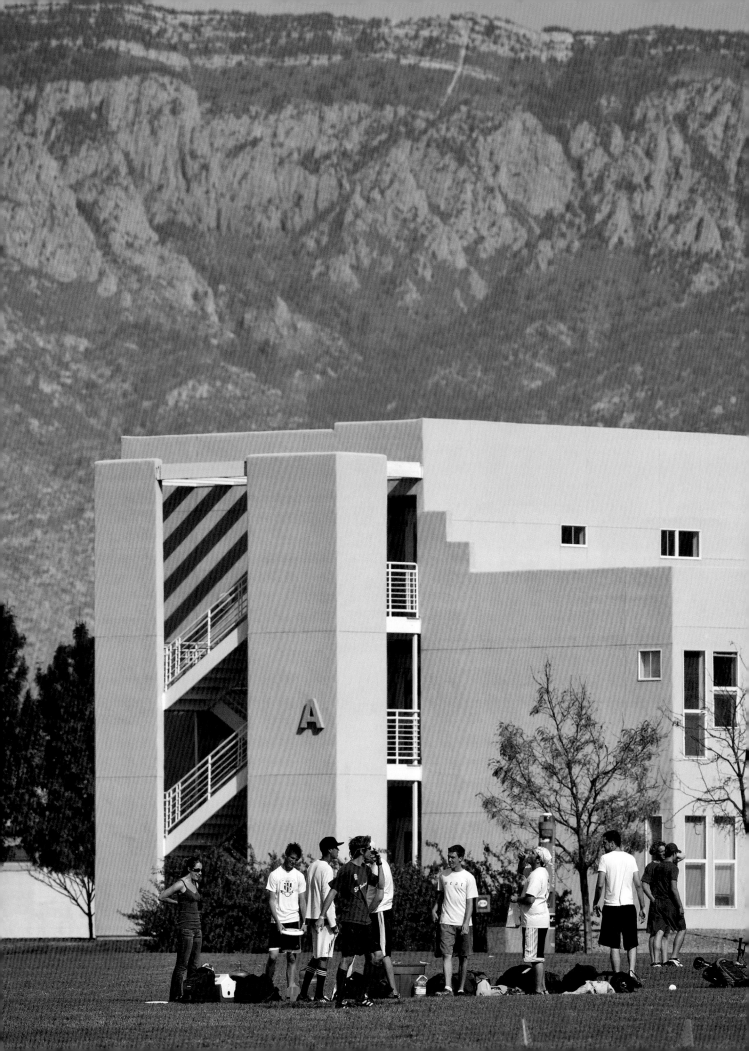

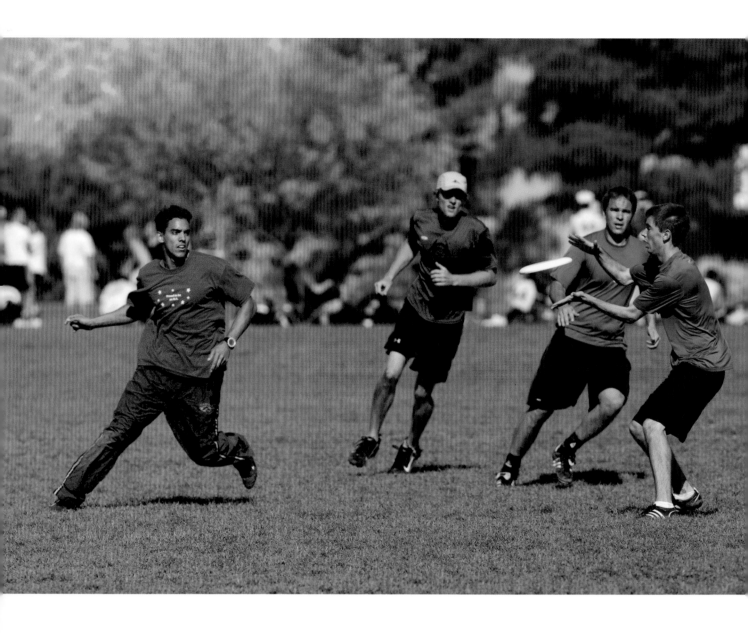

INTRAMURAL GAME ON JOHNSON FIELD

PETE AND NANCY DOMENICI MIND HALL, THE MIND INSTITUTE

▲ UNM HOSPITAL, NORTH SIDE

ENTRANCE TO CENTENNIAL SCIENCE AND ENGINEERING LIBRARY ➤

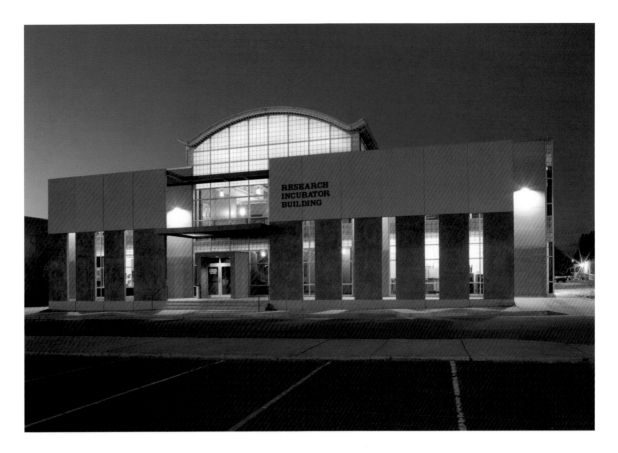

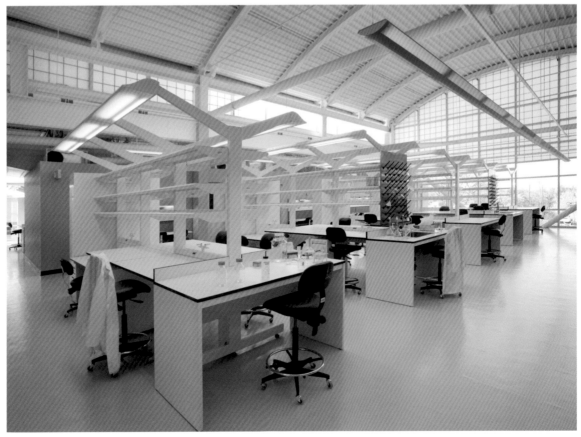

▲ RESEARCH INCUBATOR BUILDING, EXTERIOR AND INTERIOR

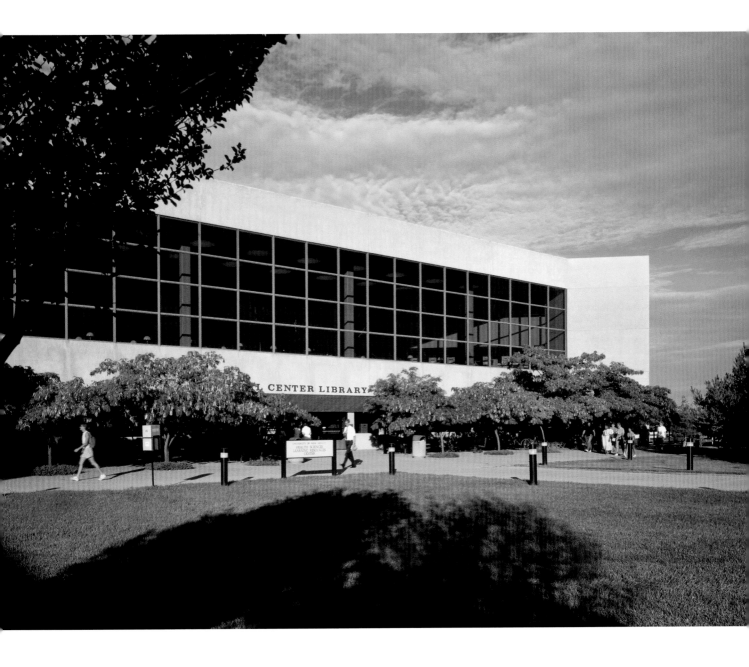

HEALTH SCIENCES LIBRARY

11

~11~
Side A
ANADIAN JOURNAL OF
SURGERY
TO
CANCER CELLS

~11~
Side B
CANCER
CHEMOTHERAPY &
PHARMACOLOGY
TO
CANCER RESEARCH

HEALTH SCIENCES LIBRARY INTERIOR

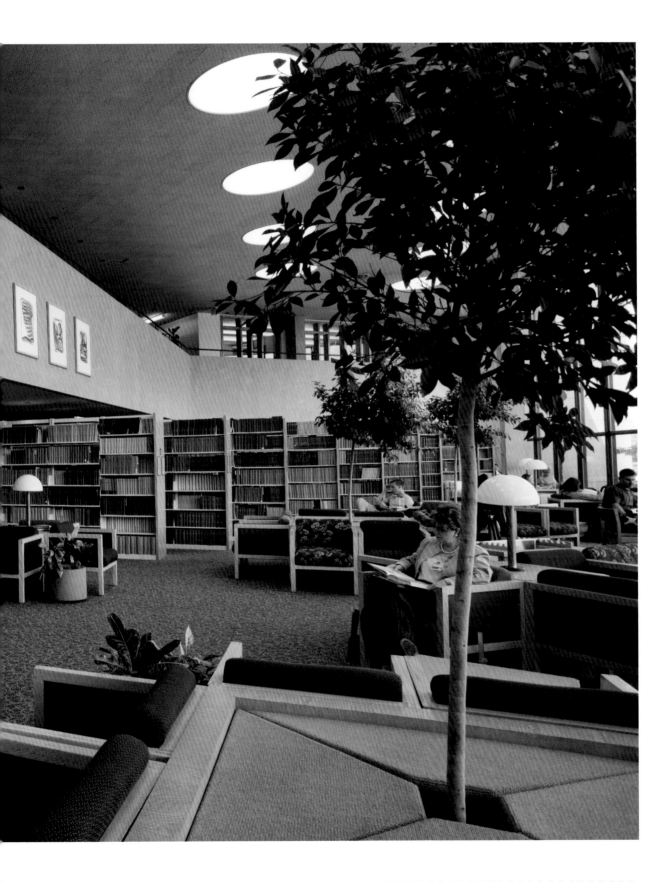

MANUFACTURING TECHNOLOGY AND TRAINING CENTER

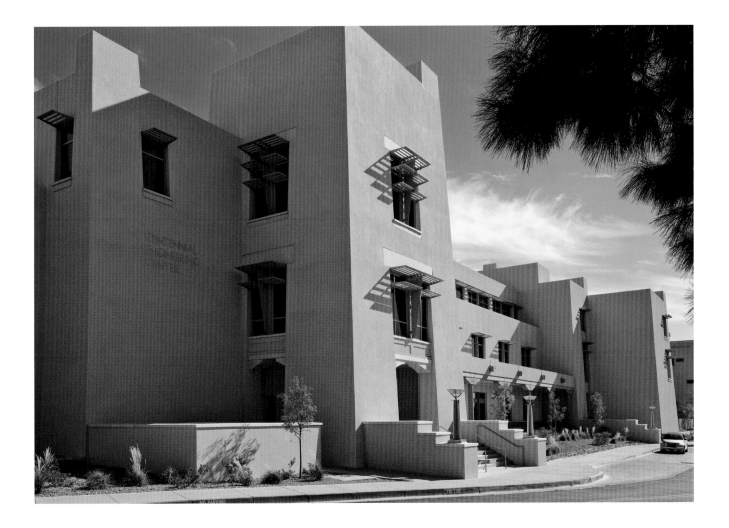

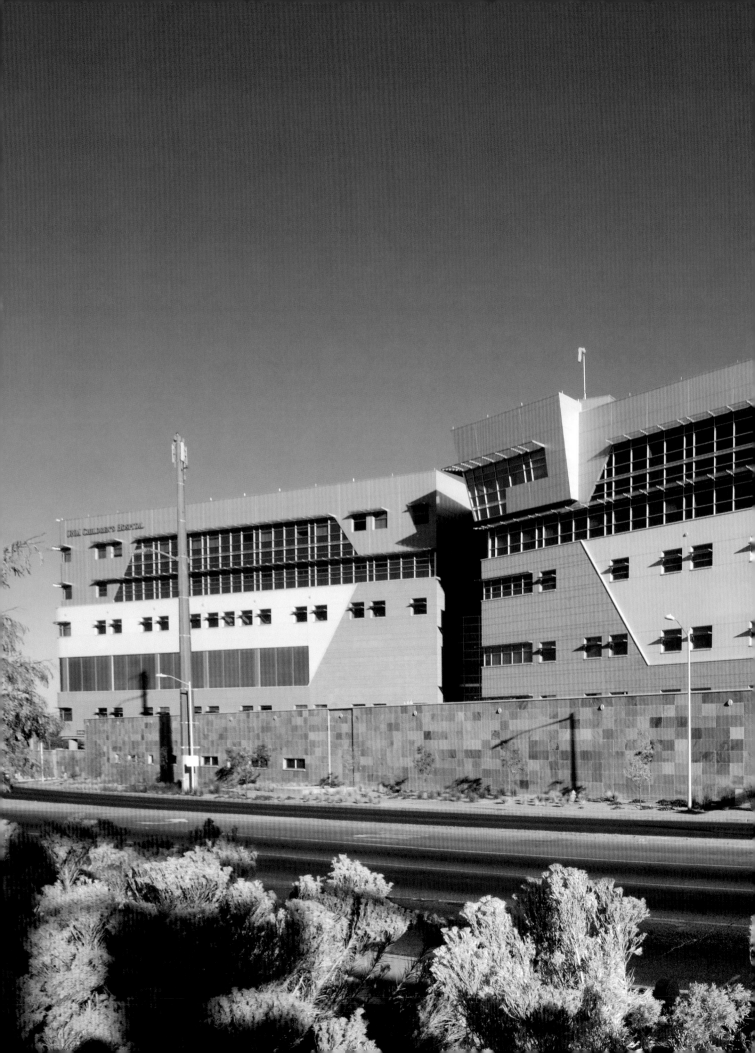

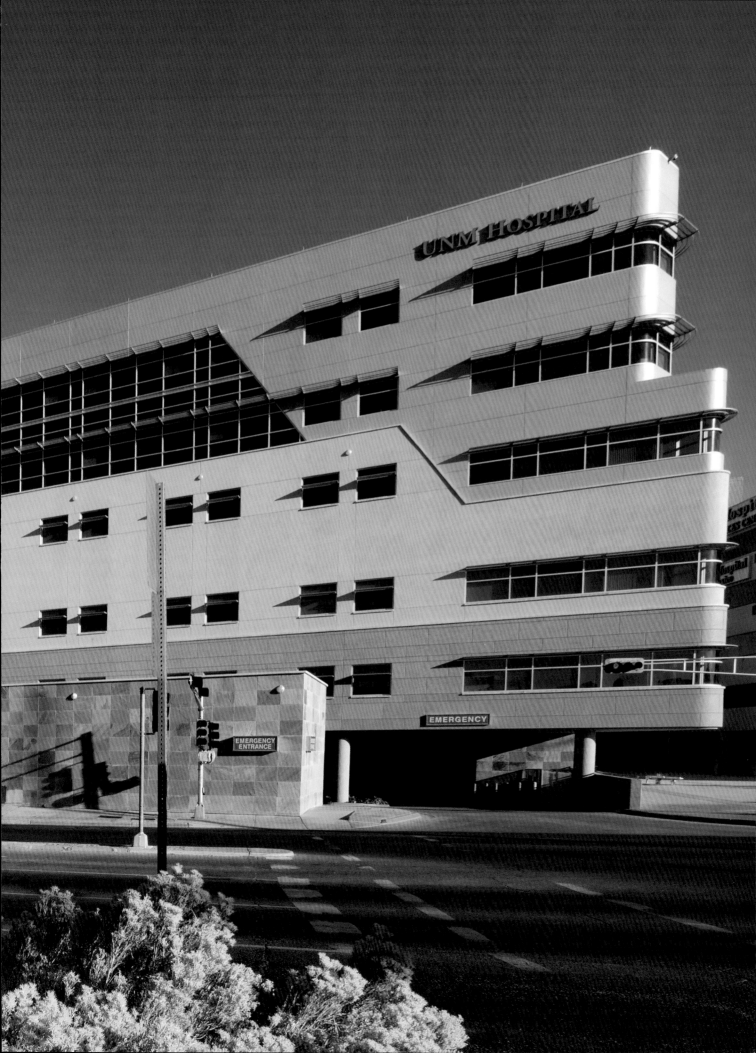

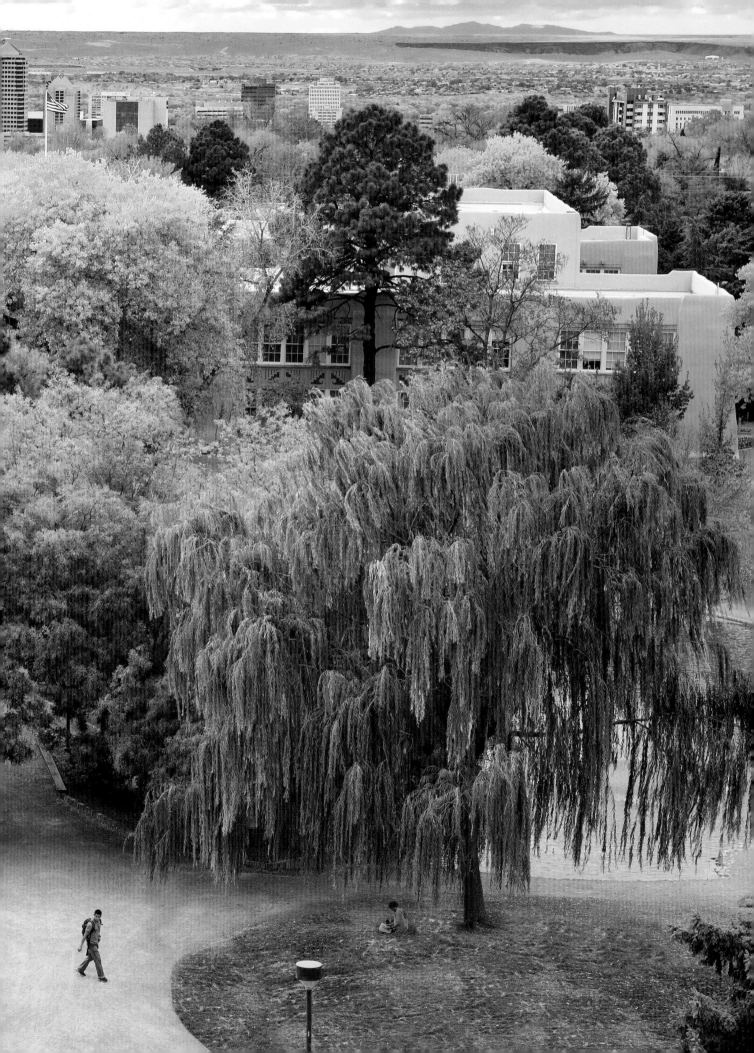

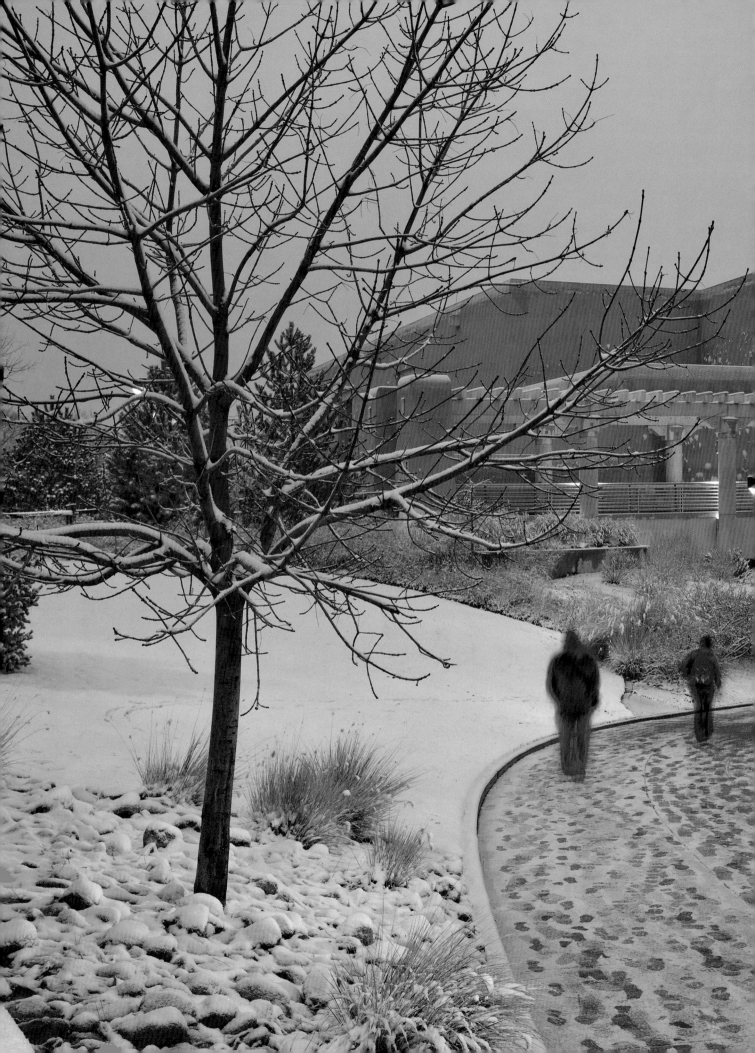

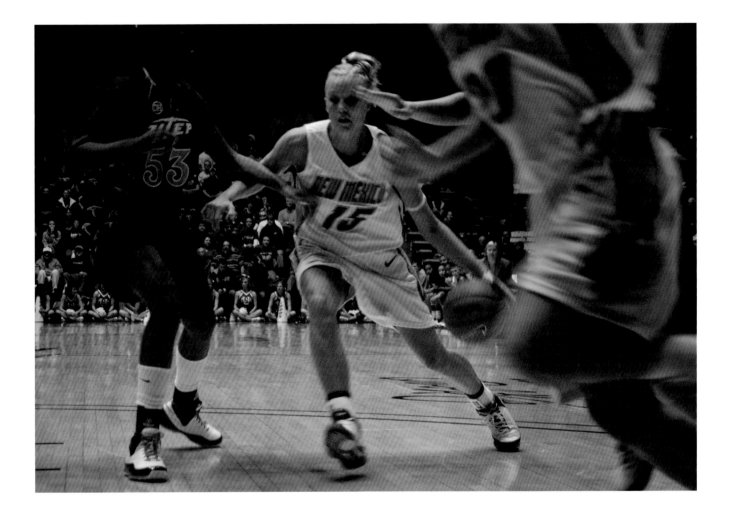

LOBO WOMEN'S BASKETBALL

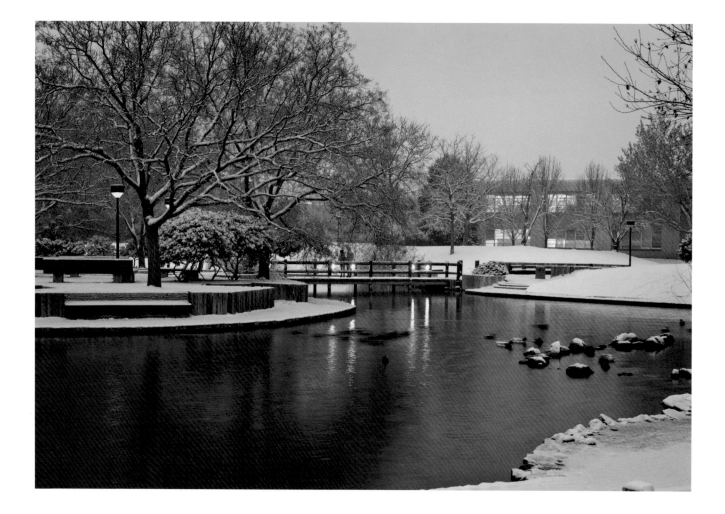

THE DUCK POND IN WINTER

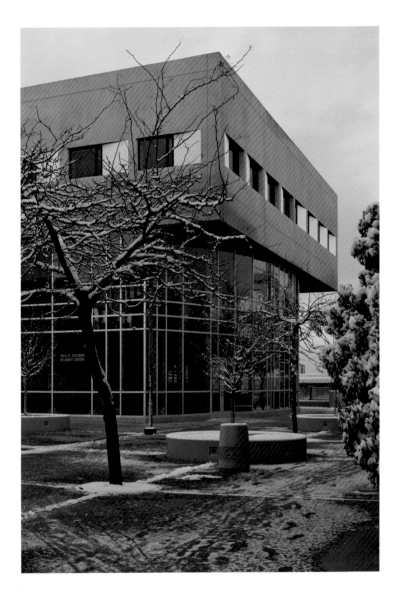

ANDERSON SCHOOL OF MANAGEMENT

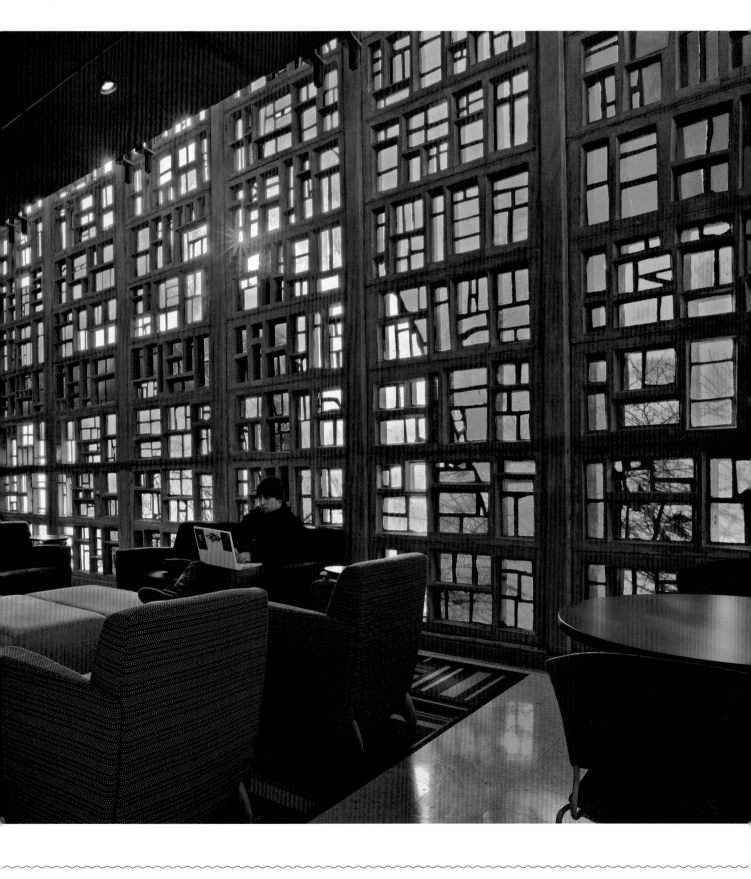

FACETED GLASS WALL, COLLEGE OF EDUCATION

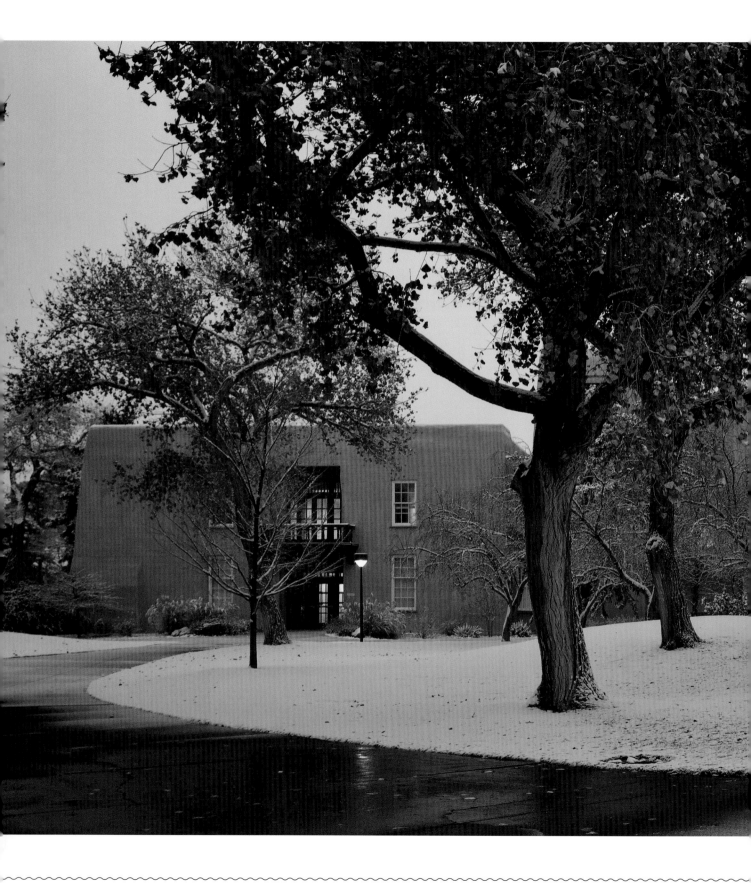

SCHOLES HALL

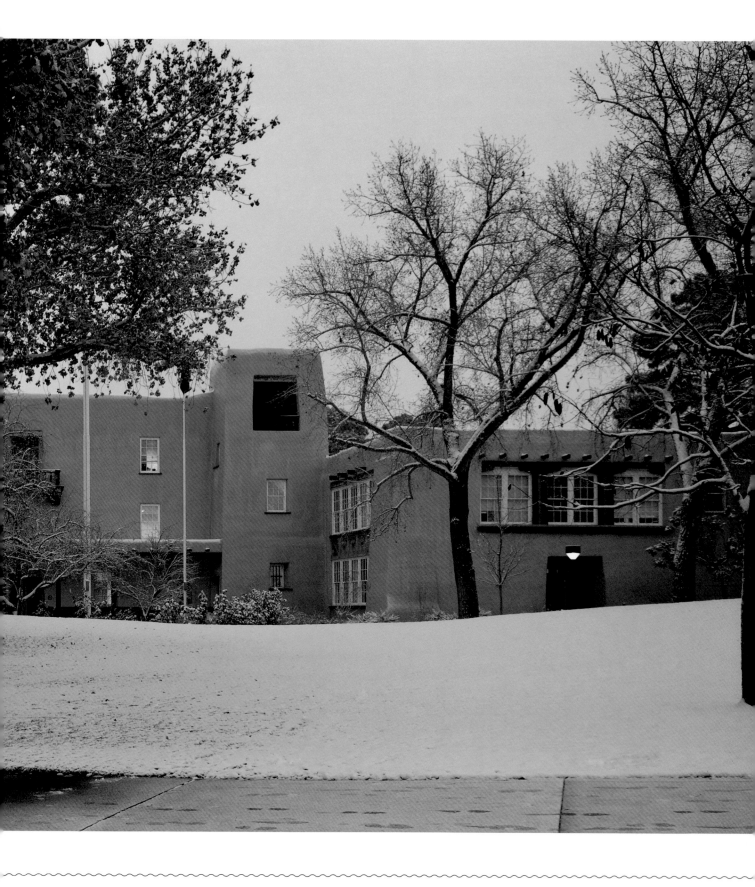

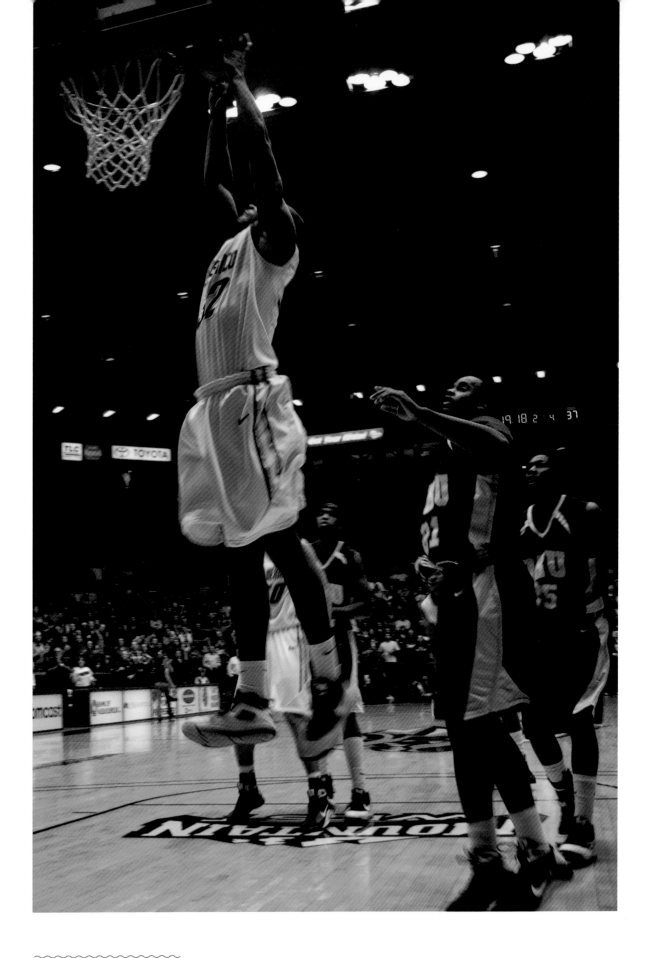

LOBO MEN'S BASKETBALL

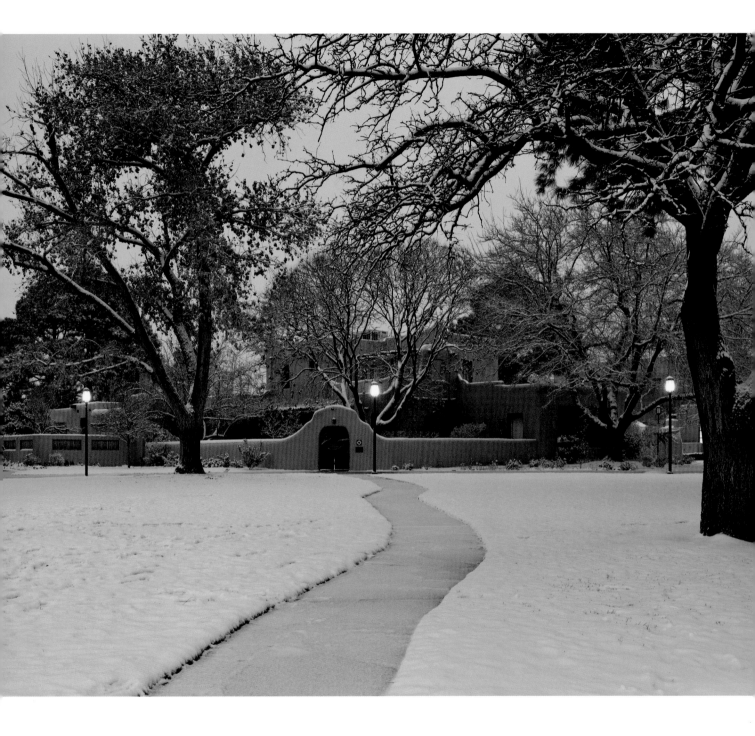

UNIVERSITY HOUSE

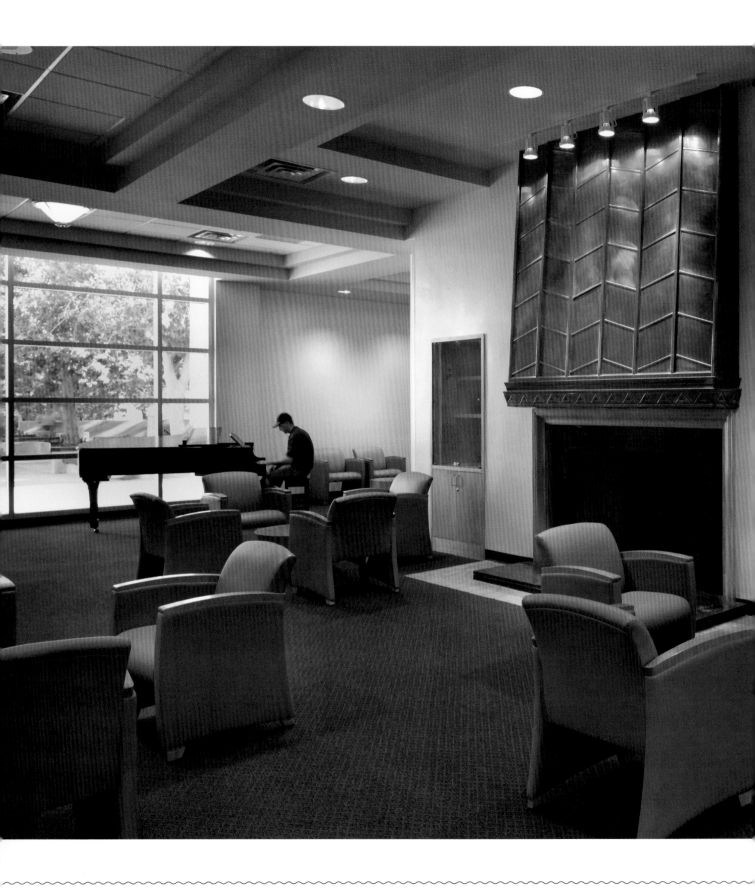

STUDENT UNION BUILDING LOUNGE

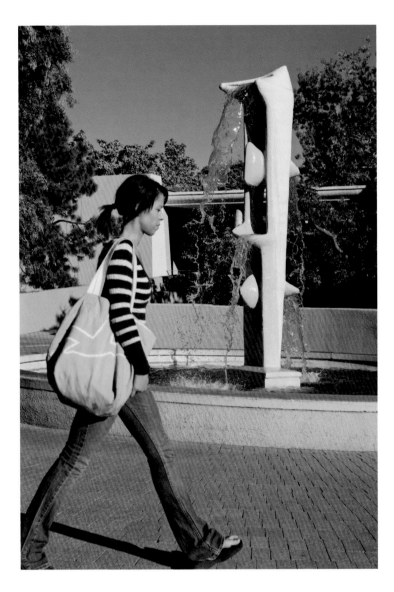

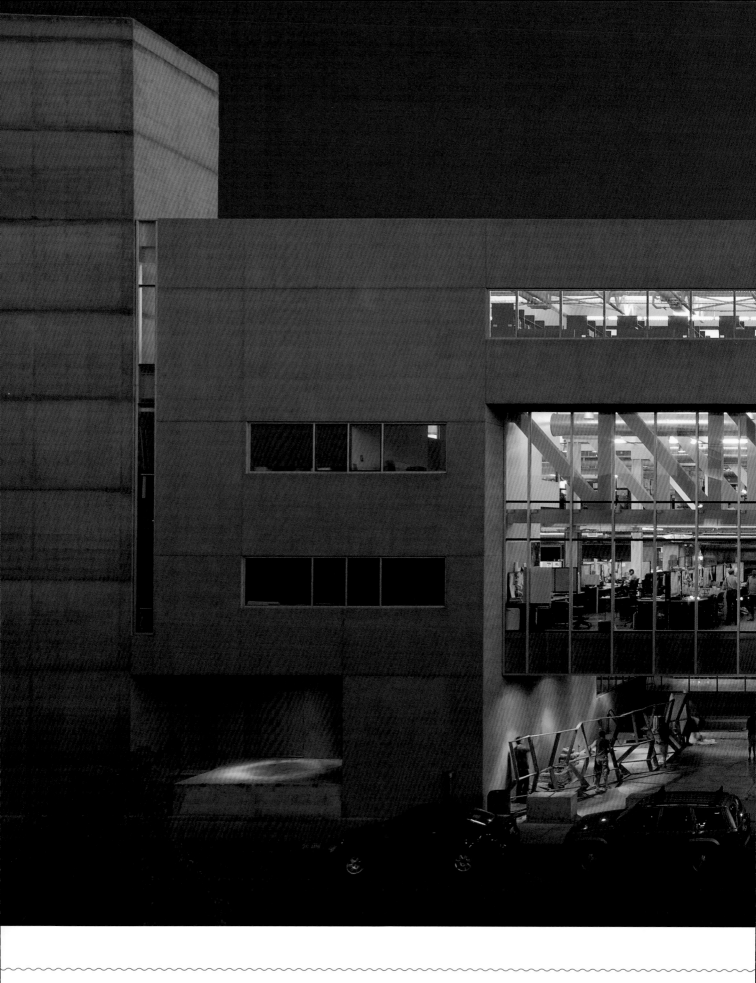

GEORGE PEARL HALL

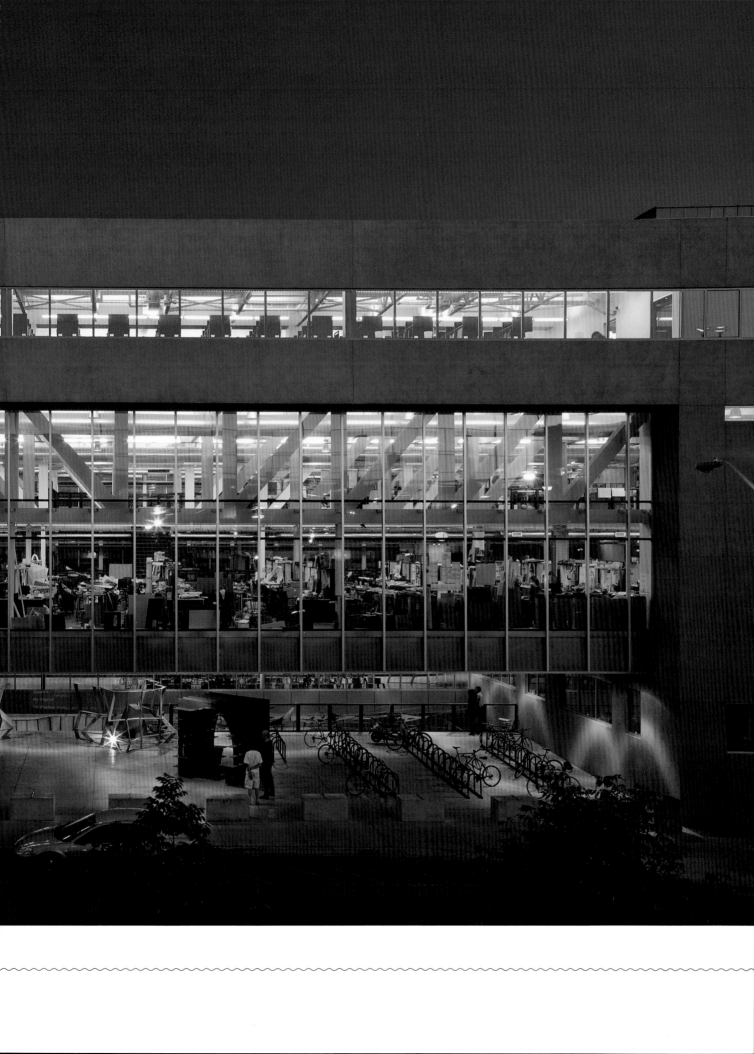

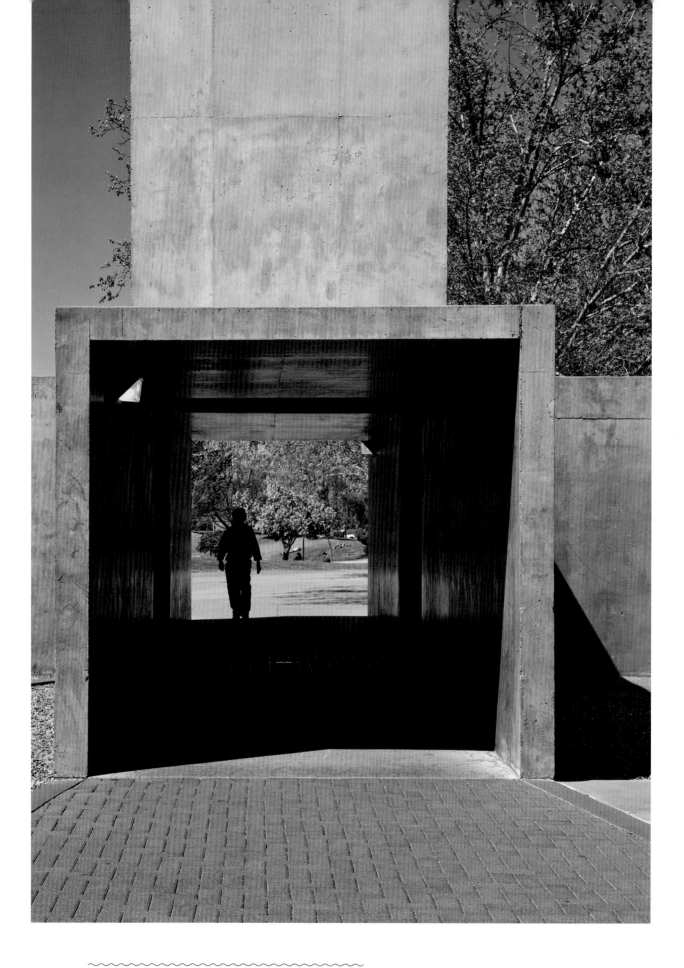

CENTER OF THE UNIVERSE, BY BRUCE NAUMAN

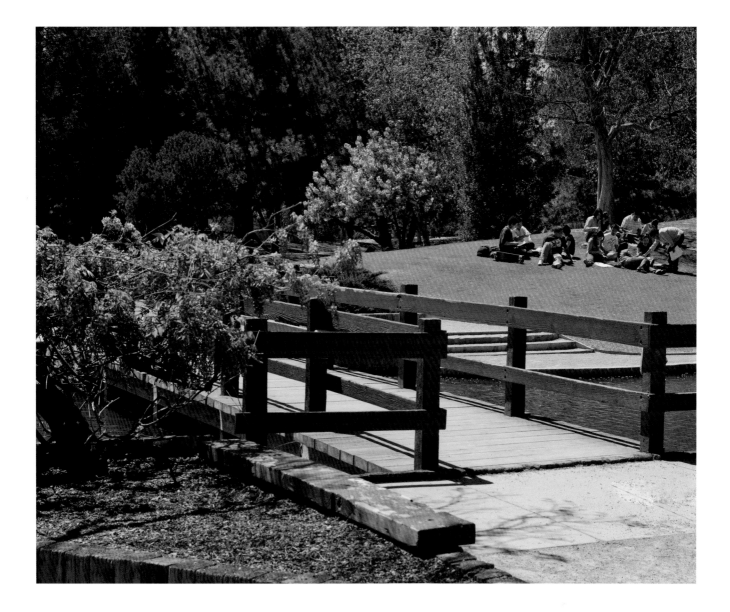

BRIDGE OVER DUCK POND

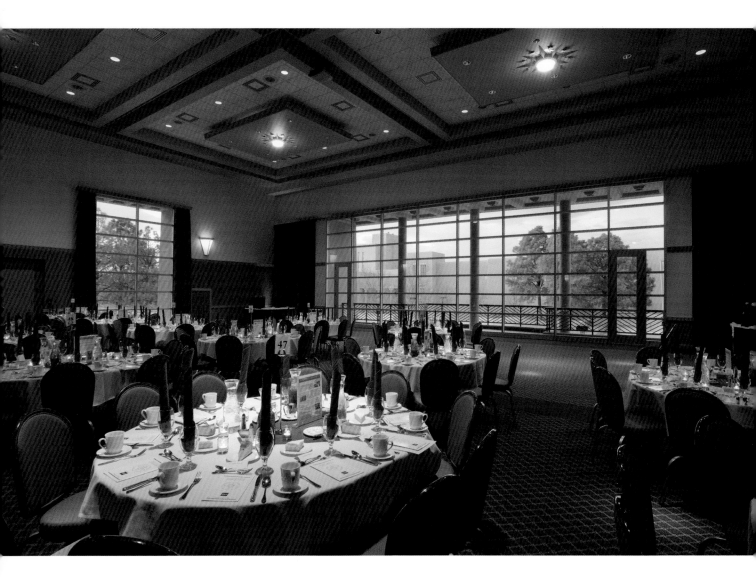

BALLROOM, STUDENT UNION BUILDING

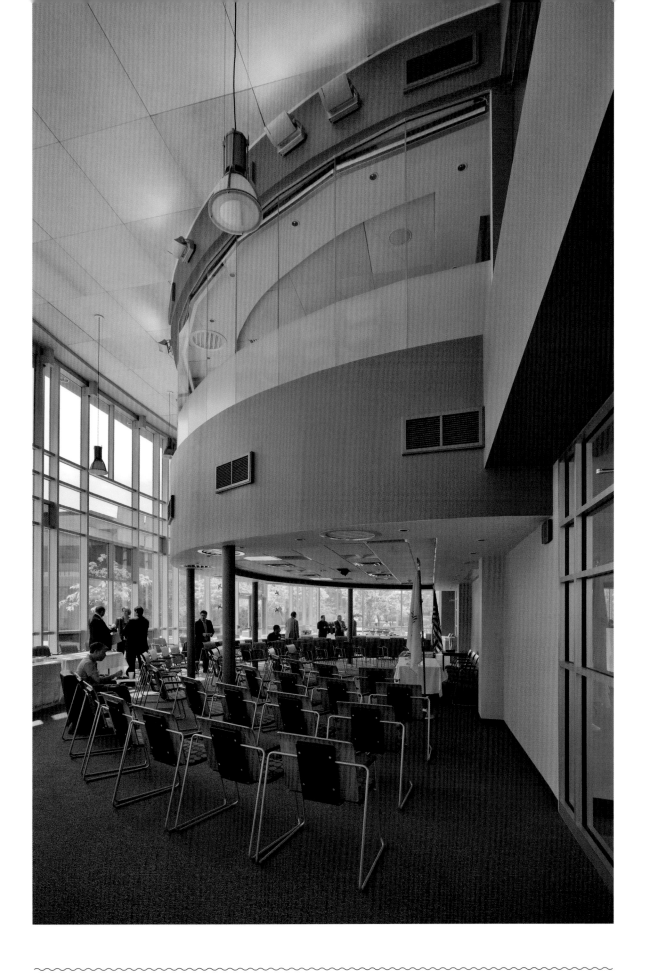

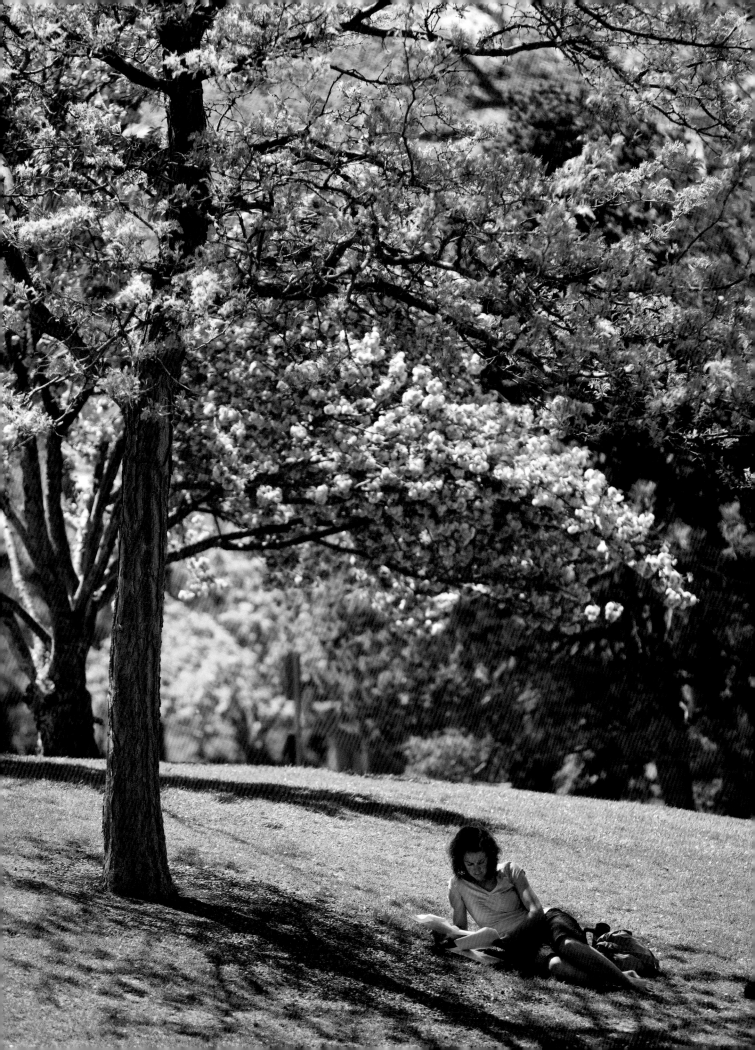

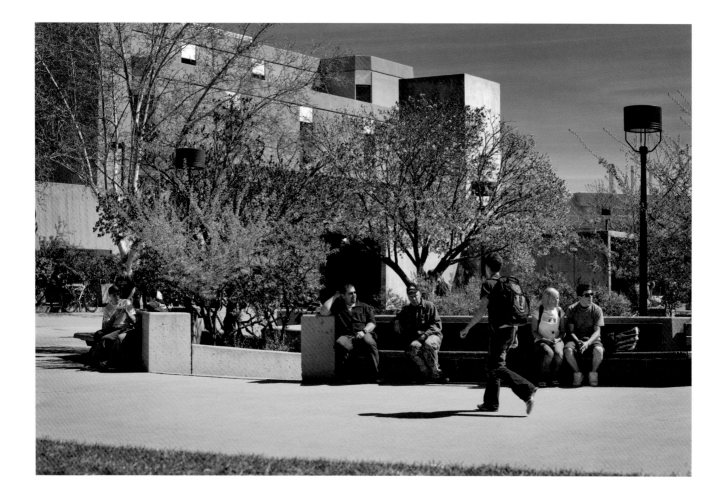

SPRING FEVER

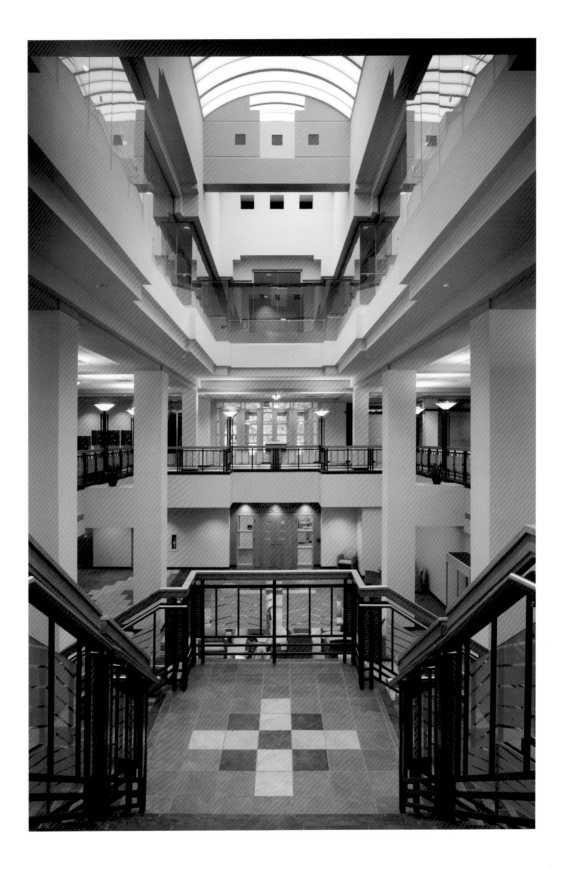

STUDENT UNION BUILDING

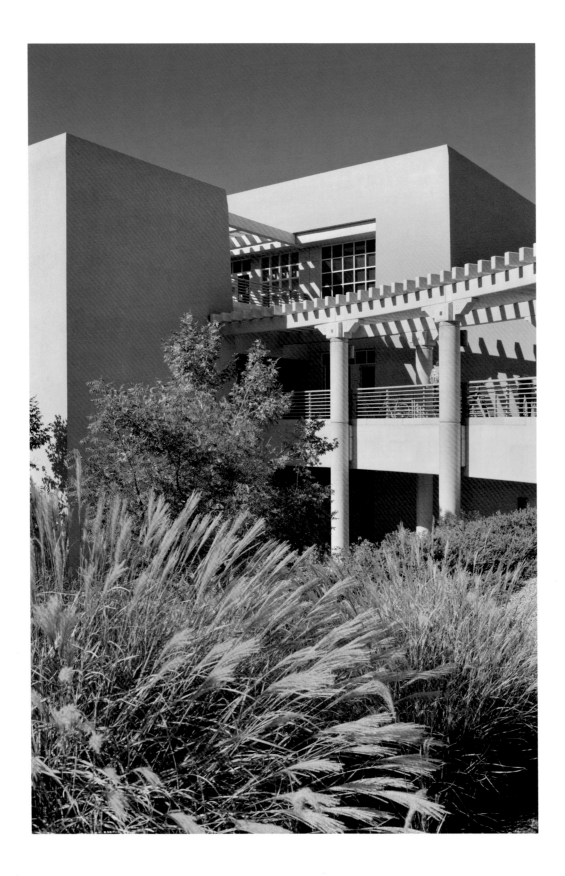

DANE SMITH HALL

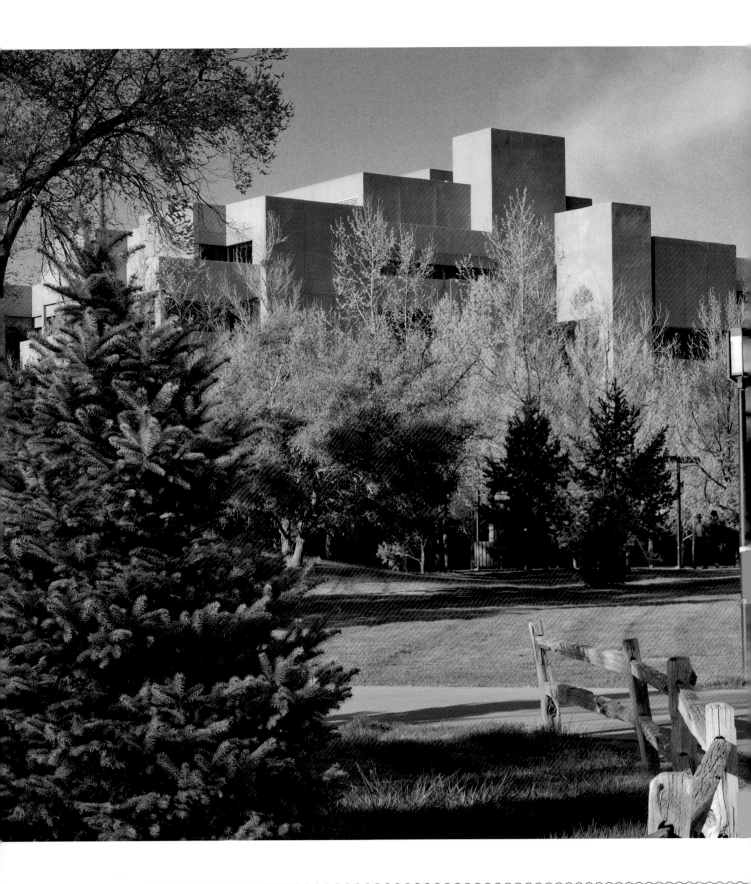

HUMANITIES BUILDING

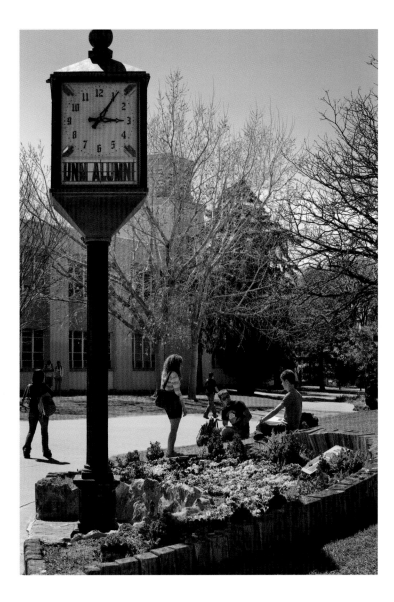

CLOCK AT THE DUCK POND

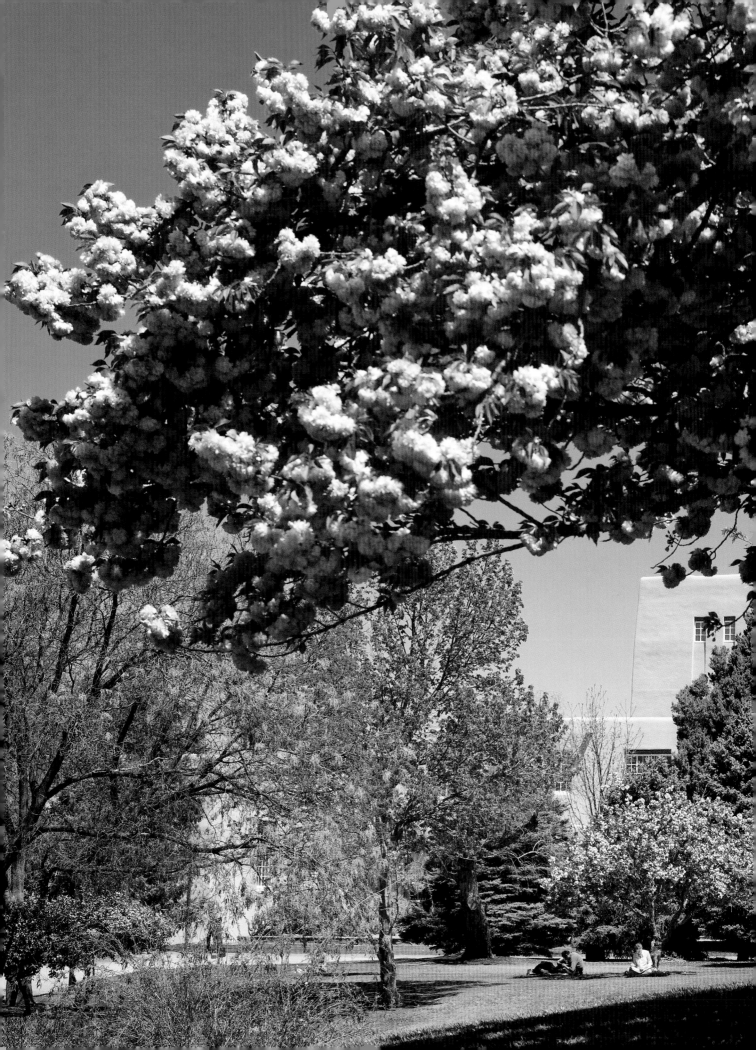

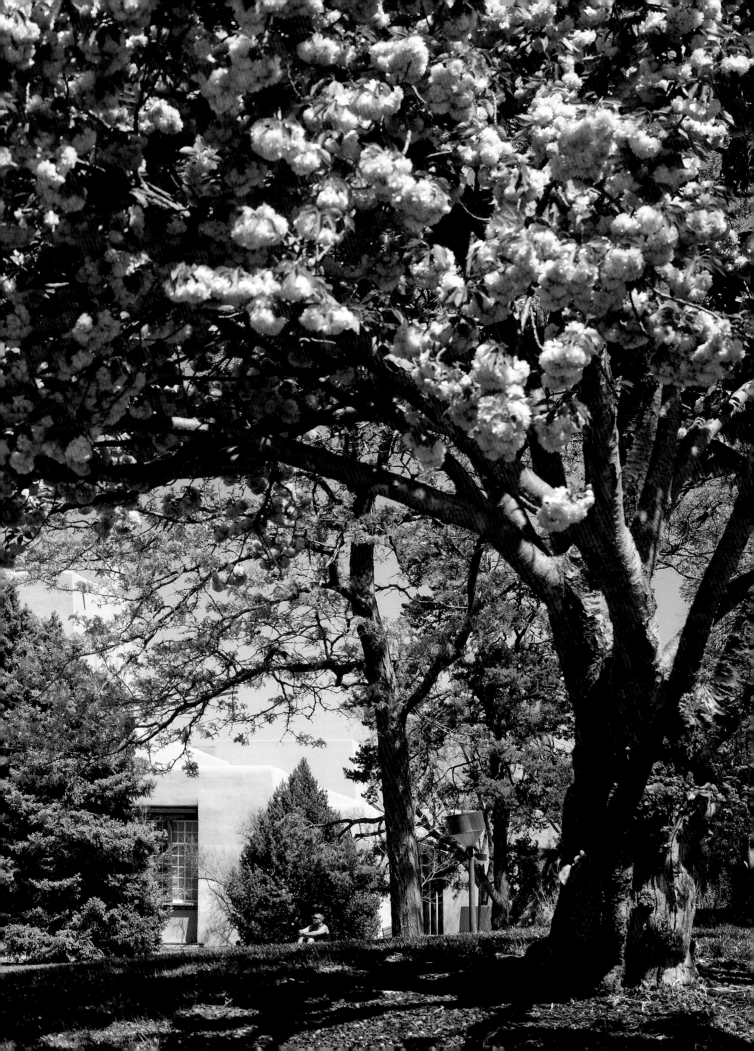

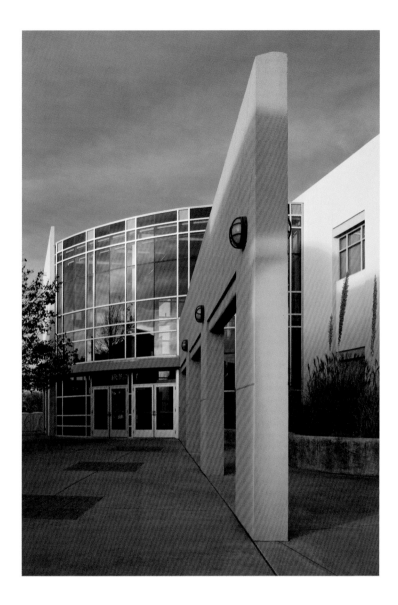

SCIENCE AND TECHNOLOGY PARK

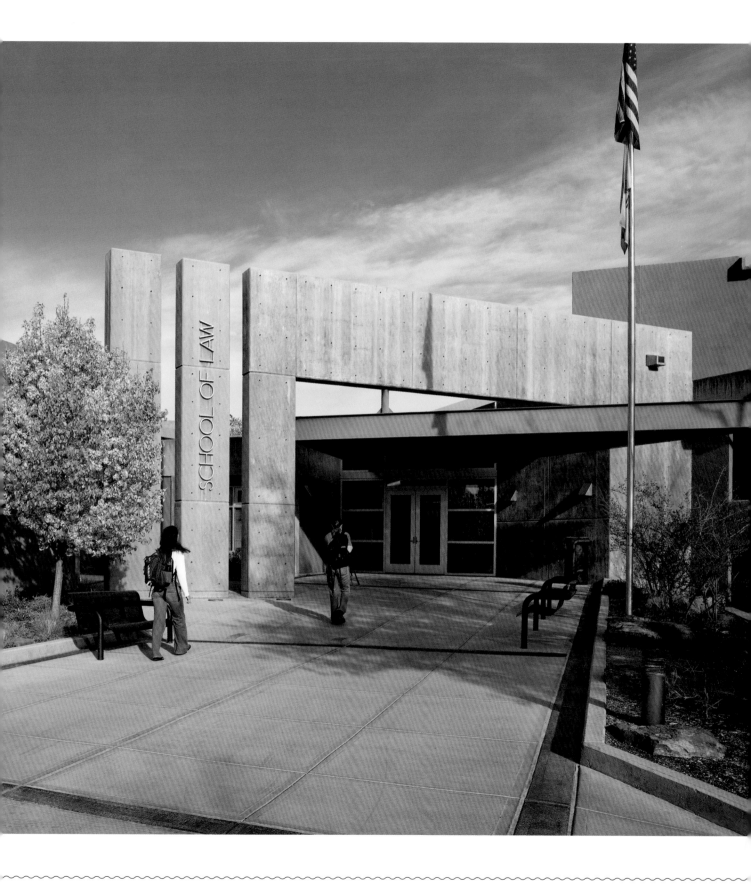

BRATTON HALL, UNM LAW SCHOOL ENTRANCE

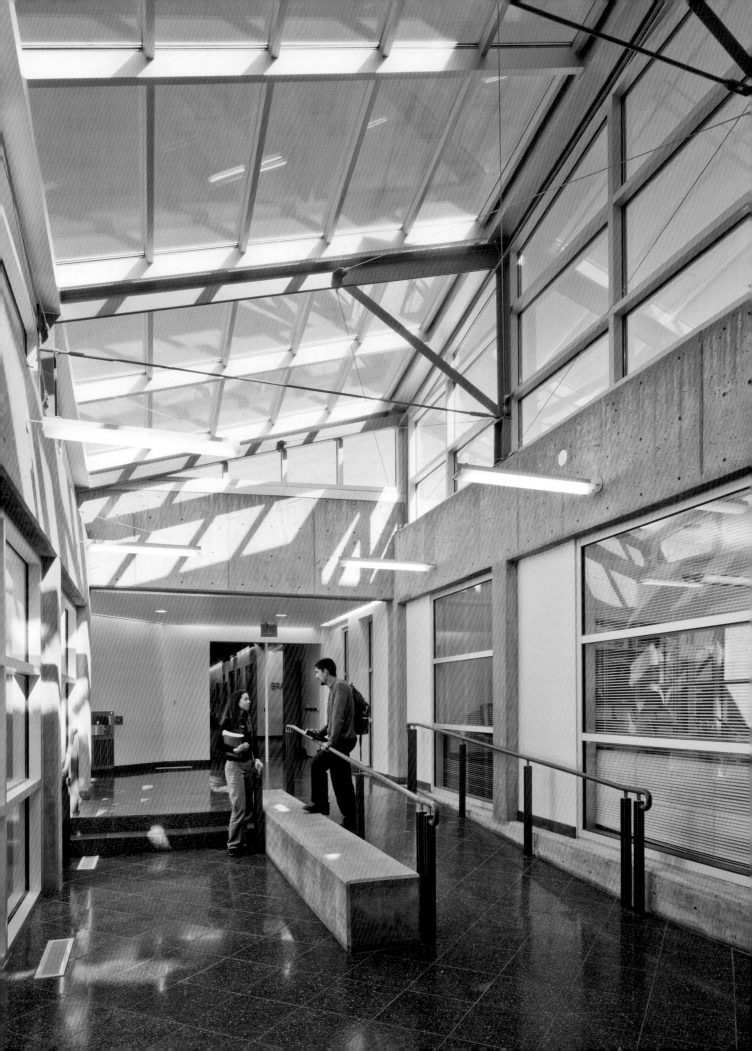

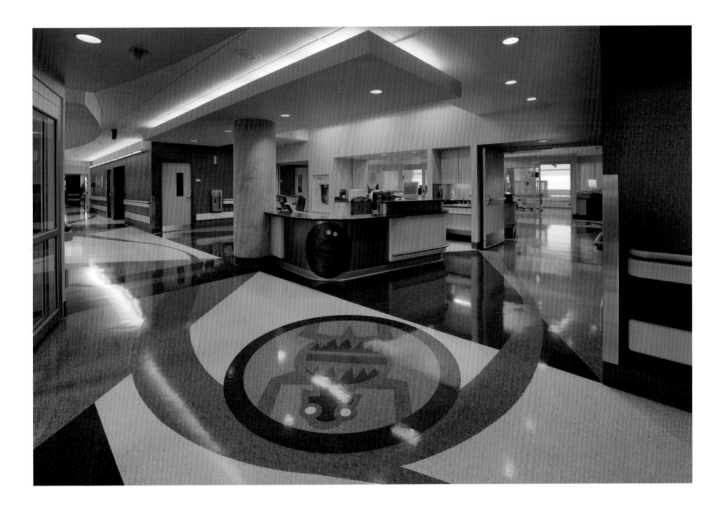

◄ BRATTON HALL, UNM LAW SCHOOL ▲ UNM HOSPITAL

HEALTH SCIENCES AND SERVICES BUILDING

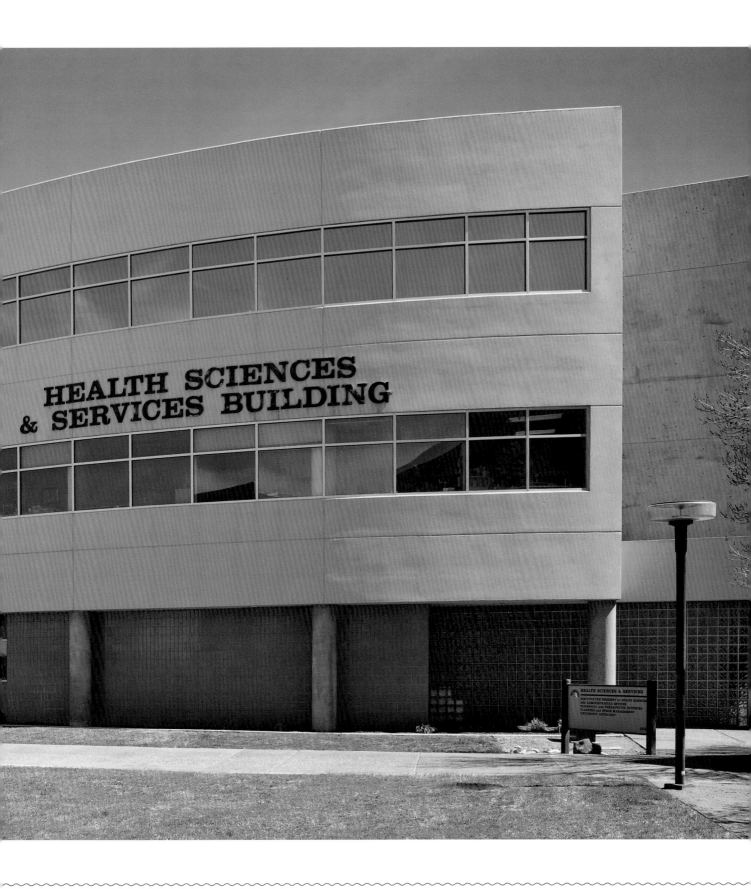

UNM CHILDREN'S HOSPITAL, MULTI-MEDIA CENTER

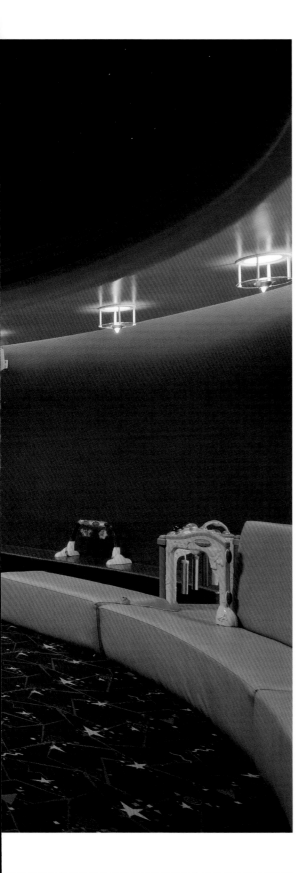

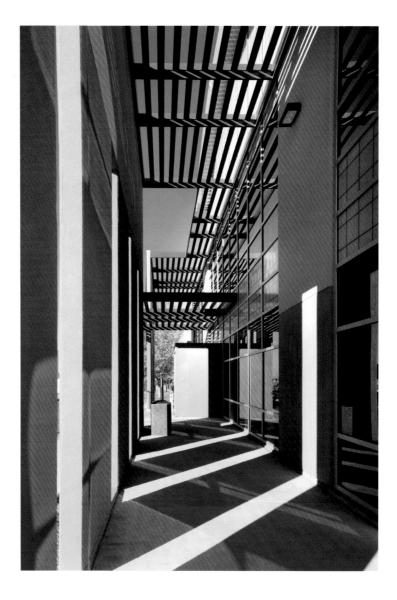

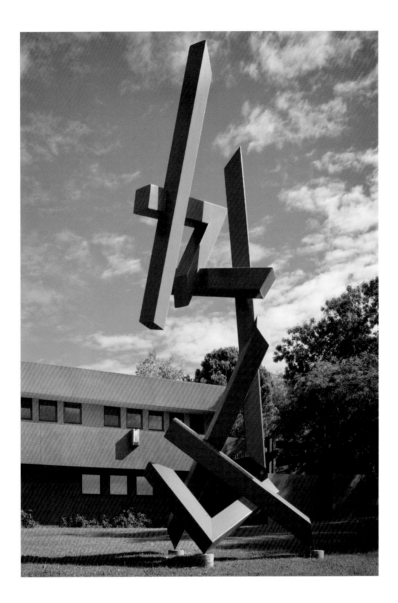

SHAW'S SCULPTURE, CHILDREN'S PSYCHIATRIC CENTER

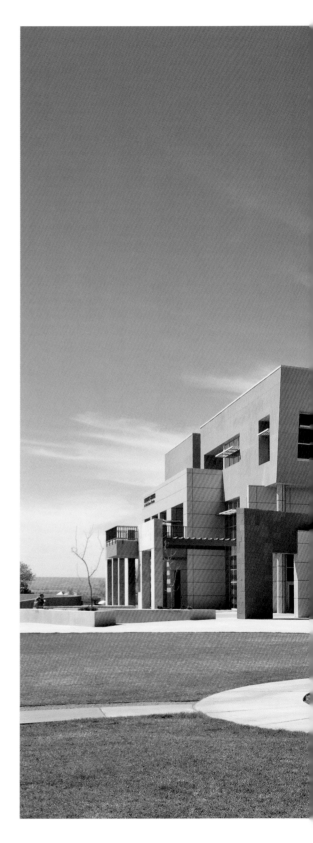

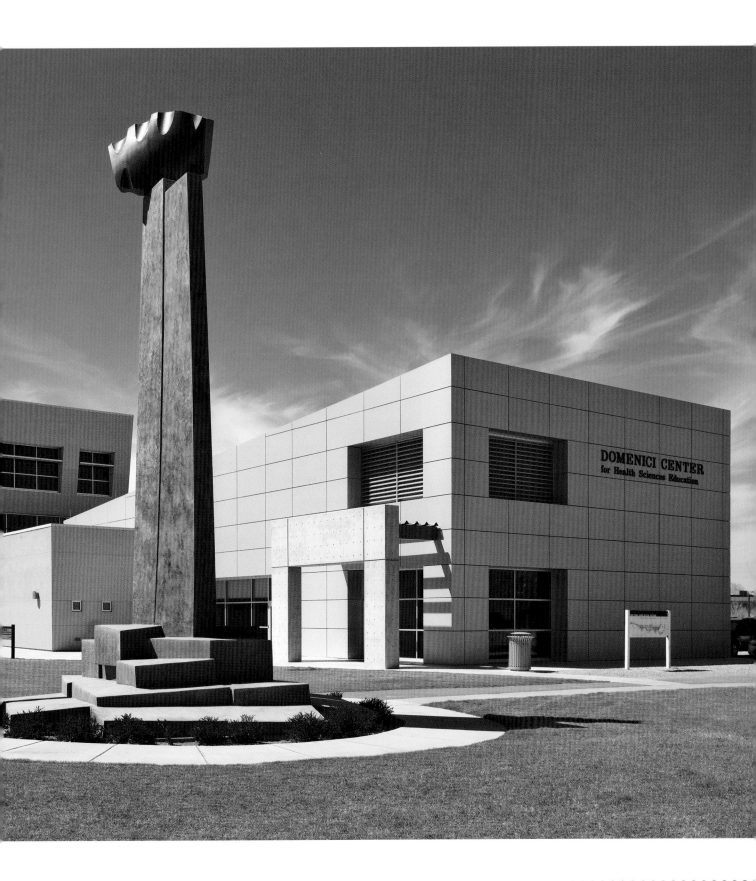

DOMENICI CENTER FOR HEALTH SCIENCES EDUCATION

DIKEWOOD BUILDING

SCIENCE AND TECHNOLOGY PARK

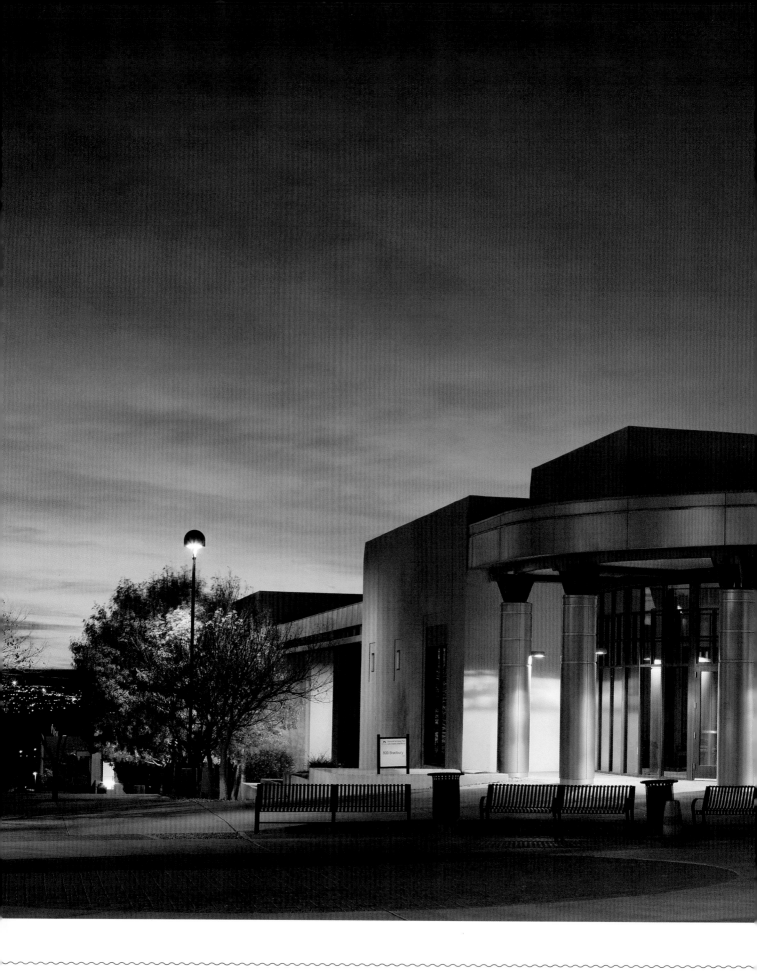

MANUFACTURING TRAINING AND TECHNOLOGY CENTER

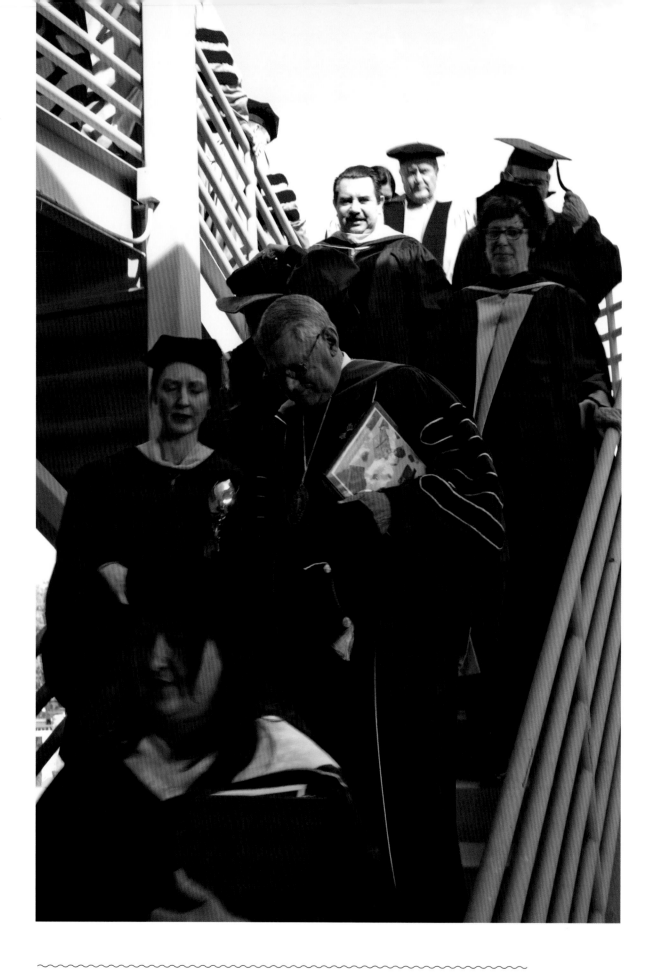

PRESIDENT SCHMIDLY, PROVOST SUZANNE ORTEGA, AND OTHERS AT GRADUATION

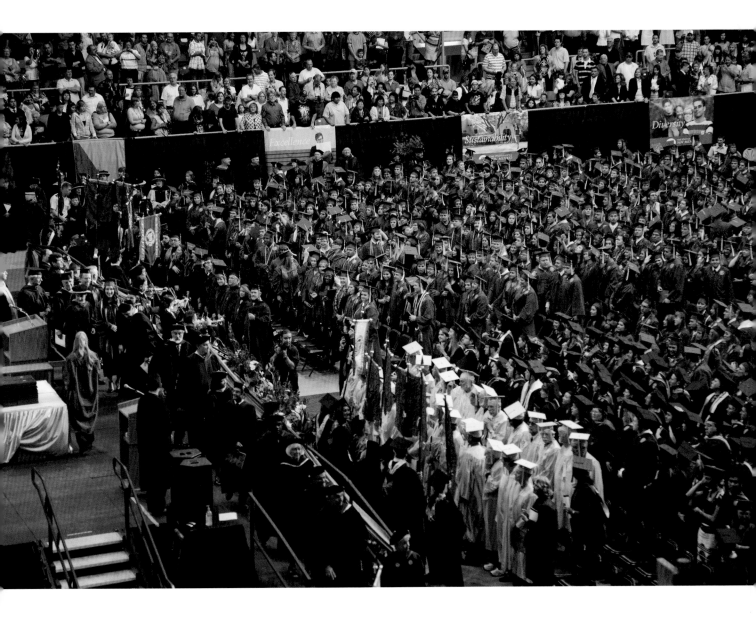

COMMENCEMENT 2009

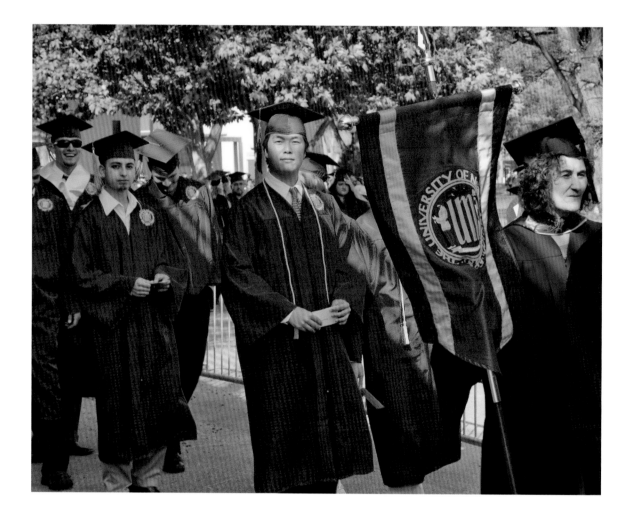

STUDENTS AT GRADUATION

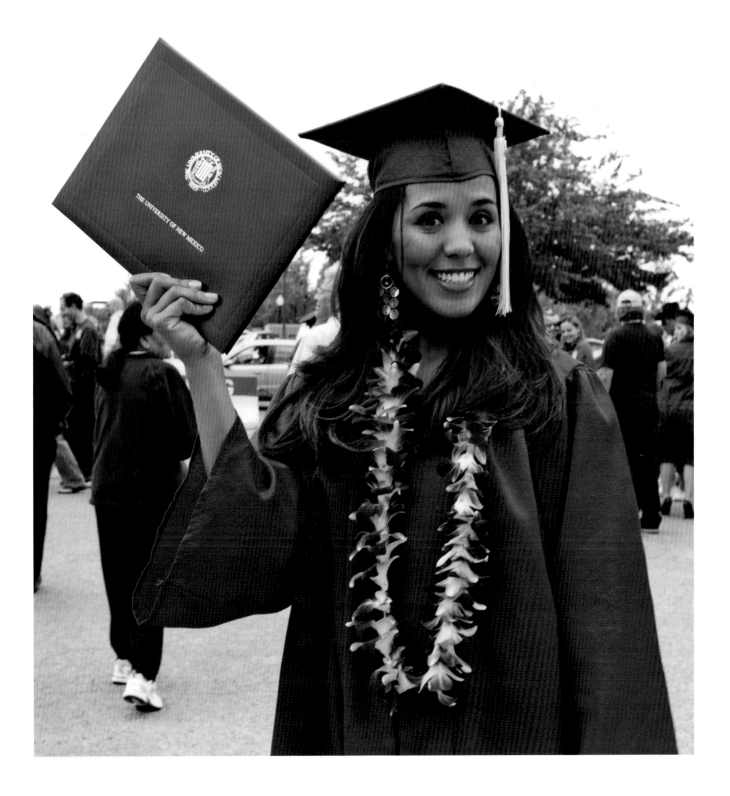

YOUNG WOMAN WITH DIPLOMA

THE PIT, UNM BASKETBALL ARENA

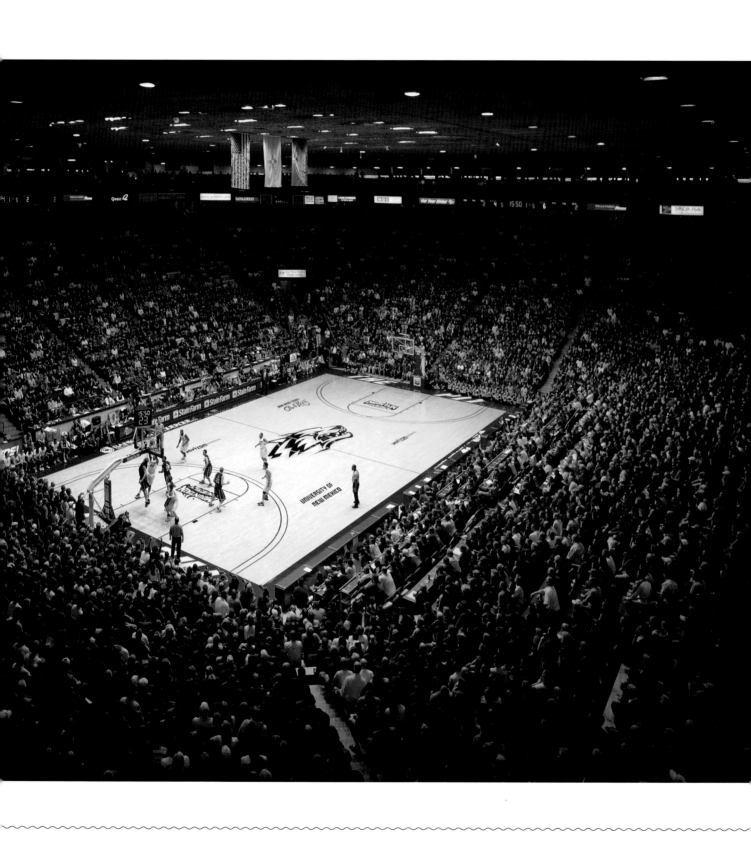